T0237958

SpringerBriefs in Research and In Governance

Editors-in-Chief

Doris Schroeder, Centre for Professional Ethics, University of Central Lancashire, Preston, Lancashire, UK

Konstantinos Iatridis, School of Management, University of Bath, Bath, UK

SpringerBriefs in Research and Innovation Governance present concise summaries of cutting-edge research and practical applications across a wide spectrum of governance activities that are shaped and informed by, and in turn impact research and innovation, with fast turnaround time to publication. Featuring compact volumes of 50 to 125 pages, the series covers a range of content from professional to academic. Monographs of new material are considered for the SpringerBriefs in Research and Innovation Governance series. Typical topics might include: a timely report of state-of-the-art analytical techniques, a bridge between new research results, as published in journal articles and a contextual literature review, a snapshot of a hot or emerging topic, an in-depth case study or technical example, a presentation of core concepts that students and practitioners must understand in order to make independent contributions, best practices or protocols to be followed, a series of short case studies/debates highlighting a specific angle. SpringerBriefs in Research and Innovation Governance allow authors to present their ideas and readers to absorb them with minimal time investment. Both solicited and unsolicited manuscripts are considered for publication.

More information about this series at http://www.springer.com/series/13811

Petru Sandu · Valentina Tudisca · Adriana Valente
Editors

Co-creating in Schools Through Art and Science

Lessons Learned in Community Engagement
Within the Responsible Research
and Innovation Framework

 Springer

Editors
Petru Sandu
Department of Public Health
Babe-Bolyai University (UBB)
Cluj-Napoca, Romania

Adriana Valente
Institute for Research on Population
and Social Policies
National Research Council of Italy
(CNR-IRPPS)
Rome, Italy

Valentina Tudisca
Institute for Research on Population
and Social Policies
National Research Council of Italy
(CNR-IRPPS)
Rome, Italy

ISSN 2452-0519 ISSN 2452-0527 (electronic)
SpringerBriefs in Research and Innovation Governance
ISBN 978-3-030-72689-8 ISBN 978-3-030-72690-4 (eBook)
https://doi.org/10.1007/978-3-030-72690-4

This Springer imprint is published by the registered company Springer Nature Switzerland AG
The registered company address is: Gewerbestrasse 11, 6330 Cham, Switzerland

Acknowledgements

The volume editors wish to acknowledge the following program committee members of the RRI-SIS 2018 Co-create! Conference for their rigorous review of the chapters that were accepted for inclusion in this book:

Sveva Avveduto, Institute for Research on Population and Social Policies of the National Research Council of Italy, Rome, Italy

Balint Balázs, Environmental social science research group, Budapest, Hungary

Silvia Caravita, Consultant, Didactic of Science Expert, Italy

Graça S. Carvalho, University of Minho, Braga, Portugal

Chiara Cavallaro, Institute for the Study of Regionalism, Federalism and Self-Government of the National Research Council of Italy, Rome, Italy

Claudia Ceccarelli, Institute for Complex Systems of the National Research Council of Italy, Rome, Italy

Fiona Catherine Chambers, University College Cork, Cork, Ireland

Antonella Ciocia, Institute for Research on Population and Social Policies of the National Research Council of Italy, Roma, Italy

Paola De Castro, National Institute of Health of Italy, Rome, Italy

Marco De Cave, Futuro Digitale Non-profit Association, Cosenza, Italy

Anna-Liisa Elorinne, University of Eastern Finland, Joensuu, Finland

Elisabetta Falchetti, ECCOM Association, Rome, Italy

Giordana Francia, The International Committee for the Development of Peoples, Rome, Italy

Peter Gray, Norwegian University of Science and Technology, Trondheim, Norway

Erich Griessler, Institute for Advanced Studies, Vienna, Austria

Claudia Gina Hassan, University of Rome Tor Vergata, Rome, Italy

Alba L'Astorina, The Institute for Electromagnetic Sensing of the Environment of the National Research Council of Italy, Milan, Italy

Paolo Landri, Institute for Research on Population and Social Policies of the National Research Council of Italy, Fisciano, Italy

Daniela Luzi, Institute for Research on Population and Social Policies of the National Research Council of Italy, Rome, Italy

Michela Mayer, Institute for Research on Population and Social Policies of the National Research Council of Italy and Science Education/Sustainability Education expert, Rome, Italy
Marisa Michelini, Udine University and the International Research Group on Physics Teaching
Claudia Pennacchiotti, Institute for Research on Population and Social Policies of the National Research Council of Italy, Rome, Italy
Marco Pennacchiotti, Principal Engineer at BMW, Munich, Germany
Sébastien Pesce, Université François-Rabelais, Tours, France
Gema Revuelta De La Poza, Pompeu Fabra University, Barcelona, Spain
Paolo Russo, Stati Generali dell'Innovazione, Rome, Italy
Charly Ryan, The University of Winchester, Winchester, the UK
Sabah Selmaoui, Université Cadi Ayyad, Marrakech, Maroc
Zacharoula Smyrnaiou, National and Kapodistrian University of Athens, Athens, Greece
Menelaos Sotiriou, Science View, Athens, Greece
Norbert Steinhaus, Bonn Science Shop, Bonn, Germany
Michael Strähle, Science Shop Vienna, Vienna, Austria
Christine Urban, Science Shop Vienna, Vienna, Austria
Andrea Vargiu, University of Sassari, Sassari, Italy
Rachele Villani, Fondazione Bruno Kessler, Trento, Italy
Vania Virgili, National Institute for Nuclear Physics, Rome, Italy
Nina Zugic, Consultant, the UK

The editors also wish to acknowledge the Marina Project for promoting the RRI-SIS 2018 Multi-conference and the Science Centre AHHAA of Tartu for the valuable support in the organization of the conference.

Finally, the editors wish to acknowledge Cristiana Crescimbene (CNR, Italy) for contributing to the editing of the volume and Leda Caterina Spiller for the final proofreading.

Contents

Editors and Contributors

About the Editors

Petru Sandu is a MD, Ph.D., Associate Researcher at the Department of Public Health, Babeș-Bolyai University, in Cluj-Napoca, Romania. His work focuses on raising awareness at local and national levels regarding the importance of physical activity promotion for healthier communities. In the timeframe 2017–2019, he coordinated the implementation of the Erasmus + Sport project DIYPES, (www. diypes.eu), aiming at engaging high-school students from five European countries in the planning and development of their own physical education and sport classes. Currently, Dr. Sandu also works at the National Institute of Public Health in Romania, developing health education campaigns addressed primarily at school age population. Not least, he teaches public health ethics at the University Babeș-Bolyai, Department of Public Health. His main areas of interest are health education, health promotion, evidence informed policymaking, community engagement and research ethics. http:// publichealth.ro/index.php/petru-sandu/

Valentina Tudisca is a Researcher of the Institute for Research on Population and Social Policies of the National Research Council of Italy, where she works in the research group "Social Studies on Science, Education and Communication." Among her research interests are science communication; relations between evidence and decision making; participatory didactics; representations of international migrations and migrants in media and textbooks. One of her characteristics is the cross-sectorial research path, going from Physics—her Ph.D. subject–to the study of interconnections between science and society through a biennial Master in Science Communication at the Scuola Internazionale Superiore di Studi Avanzati in Trieste. https:// www.irpps.cnr.it/en/staff/valentina-tudisca-en/

Adriana Valente jurist and sociologist, is Research Director at the Institute for Research on Population and Social Policies of the National Research Council of Italy, where she works as scientific responsible of the research group "Social Studies

on Science, Education and Communication," aimed at understanding and enhancing relations between science, politics and society. Among her research interests are relations between evidence and decision making; education, didactics of science and participation to the scientific debate; science communication and scientific community; representations of international migrations and migrants on media and textbooks. https://www.irpps.cnr.it/en/staff/adriana-valente-en/

Contributors

Nicola Barbuti Department of Humanities (DISUM), University of Bari Aldo Moro, Bari, Italy

Cristina Da Milano ECCOM (European Centre for Cultural Organization and Management), Rome, Italy

Ilaria Di Tullio Institute for Research on Population and Social Policies, National Research Council, Rome, Italy

Annalisa Di Zanni Liceo Statale Classico, Linguistico e Scienze Umane "F. De Sanctis", Bari, Italy

Elisabetta Falchetti ECCOM (European Centre for Cultural Organization and Management), Rome, Italy

Ana Isabel Faustino Open Science Hub-Portugal, Municipality of Figueira de Castelo Rodrigo, Portugal

Eleni Georgakopoulou National and Kapodistrian University of Athens Ilissia, Athens, Greece

Maria Francesca Guida ECCOM (European Centre for Cultural Organization and Management), Rome, Italy

Paulo Jorge Lourenço Open Science Hub-Portugal, Municipality of Figueira de Castelo Rodrigo, Portugal

Carlos Martins Open Science Hub-Portugal, Municipality of Figueira de Castelo Rodrigo, Portugal

Ana Peso Open Science Hub-Portugal, Municipality of Figueira de Castelo Rodrigo, Portugal

Filipe Pinto Open Science Hub-Portugal, Municipality of Figueira de Castelo Rodrigo, Portugal

Lucio Pisacane Institute for Research on Population and Social Policies, National Research Council, Rome, Italy

Paolo Russo Stati Generali dell'Innovazione, Rome, Italy

Pedro Russo Astronomy & Society Group, Leiden Observatory and Dep. Science Communication and Society, Leiden University, Leiden, The Netherlands

Petru Sandu University Babes-Bolyai, Cluj-Napoca, Romania

Zacharoula Smyrnaiou National and Kapodistrian University of Athens Ilissia, Athens, Greece

Menelaos Sotiriou Science View, Athens, Greece

Sofoklis Sotiriou Ellinogermaniki Agogi, Pallini, Greece

Valentina Tudisca Institute for Research on Population and Social Policies of the National Research Council of Italy, Rome, Italy

Adriana Valente Institute for Research on Population and Social Policies of the National Research Council of Italy, Rome, Italy

Altheo Valentini Egina S.r.l., Foligno, Italy

José Varela Open Science Hub-Portugal, Municipality of Figueira de Castelo Rodrigo, Portugal

Maria Inês Vicente Open Science Hub-Portugal, Municipality of Figueira de Castelo Rodrigo, Portugal;
Astronomy & Society Group, Leiden Observatory and Dep. Science Communication and Society, Leiden University, Leiden, The Netherlands

Chapter 1
Trajectories of Art, Science and RRI—Introductory Remarks

Petru Sandu, Valentina Tudisca, and Adriana Valente

Abstract The chapter introduces the theoretical reflections which have inspired this volume, starting with the art and science relationship, following the formalization of their possible connections through the Science, Technology, Engineering, Arts and Mathematics (STEAM) approach in the educational field and finally focusing on storytelling as a specific methodology. Educational experiences of co-creation combining art and science can be seen in light of the Responsible Research and Innovation framework by emphasizing the active role of learners, teachers, scientists and other societal actors throughout the entire process of co-creation of knowledge, with the aim of aligning the research process and its consecutive outcomes with societal needs, values and expectations.

Keywords Art and science · STEAM · RRI · Co-creation

Despite being radically different according to common sense, both art and science share the need for rules and creativity and thus can be fruitfully connected. Historical examples of this connection can be traced back to the Renaissance period. The Renaissance person was equipped with knowledge and skills in various fields of activity. For example, Leonardo da Vinci was a painter, sculptor, engineer, botanist and scientist simultaneously. Another prominent example of the interrelation between art and science is represented by Marianne North's paintings of tropical plants. Active in the mid- to late nineteenth century, North traveled extensively on her own producing over 800 paintings. Charles Darwin considered North's paintings to be excellent examples of his theory of natural selection. One can see quite clearly from her work the

P. Sandu
University Babes-Bolyai, Cluj-Napoca, Romania

V. Tudisca (✉) · A. Valente
Institute for Research on Population and Social Policies of the National Research Council of Italy, Rome, Italy
e-mail: valentina.tudisca@irpps.cnr.it

A. Valente
e-mail: adriana.valente@cnr.it

1

adaptations that tropical plants went through to survive in different areas of the world and the similarities between geographically close species. North also established a legacy through several species for which she provided the first illustrations (EBSCO 2017).

A different perspective on the connection between art and science stems from medicine. A systematic literature review looking at the effects of playing music during surgery on the performance of the surgical team revealed: "positive effects of music on the performance of the surgical team, that included providing more relaxing and more pleasant environment, making them calmer, performing tasks more accurately and precisely, decreasing mental workload and task completion time, increasing situation awareness, reducing stress and anxiety and improving memory consolidation and making them to enjoy their work" (Rastipisheh et al. 2018).

Other medicine-related examples of art and science connection are art therapy and ergotherapy (occupational therapy) that combine medical procedures with different types of arts (or crafts) to improve health outcomes related to stress, mental illnesses or other neuropsychiatric conditions (Huet 2015; Radder et al. 2017).

The delineation between art and science, especially in the Western cultures, started to be made at the beginning of the nineteenth century, coinciding with the (first) Industrial Revolution and the start of the use of machines for mass production of goods (Zhu and Goyal 2018). Although more recently materialized in techniques applicable in different fields (University of Calgary 2020)—such as the STEAM approach in education that will be elaborated below—the relationship between art and science has been discussed and studied for more than 35 years now. In his 1984 paper titled "The interaction of art and science" (1984), Sheldon Richmond presents his view of functionally interdependent science and art. In this paper, Richmond argues that "science relies on the imagination of art for new hypotheses; art relies on the critical reasoning of science to awaken the imagination into activity". However, this type of explorations of the connections between art and science missed the elements of applicability, in the sense of techniques or instruments for applying common elements of art and science in diverse fields of activity.

In more recent years, there has been a rapid growth of interest in the relationship between art and science and how these could be actually used together, in practice, in order to solve societal problems and advance knowledge and well-being of populations. One of the results of these explorations is STEAM framework in the field of education.

Developed in 2006 by an MS/HS Engineering and Technology teacher, Georgette Yakman, STEAM education is an approach to learning that uses science, technology, engineering, the arts and mathematics as access points for guiding student inquiry, dialogue and critical thinking (Institute for Arts Integration and STEAM 2020). STEAM is a progression of the original STEM acronym that was introduced early in the twenty-first century as a way to refer to careers and/or curricula centered around science, technology, engineering and mathematics—the most rapidly growing industries at the time.

Why adding arts to the STEM framework? The need for using this new approach in education, the addition of arts to STEM, resulted from new societal needs (in

terms of problems to be solved and jobs to be offered to solve these problems) and changing students and parents (and educators) expectations with regard to the education system, as an integral (or even central) component in the new societal context.

Similarly to the original interest for the implementation of STEM curriculum that was driven by a rise in related job opportunities in the American economy (STEM occupations growing at that time at double the rate of all other occupations), STEAM followed the trends in the workplace market, such as automation, need for highly specialized and innovative, collaborative workers rather than unqualified/unskilled workforce (Vestberg 2018).

To be successful both now and down the road, one must understand the need to be both an analytical and a creative thinker.

Several research studies confirmed that using STEAM education results in students taking more calculated risks, engaging in experiential learning, persisting in problem-solving behavior and embracing collaboration through the creative process (Cunnington et al. 2014; Inoa et al. 2014). Integration of concepts, topics, standards and evaluations is a powerful way to disrupt the typical course of events for students and to help change the school in its classic conceptualization.

In a report titled "How the ARTS Benefit Student Achievement," the National Assembly of State Arts Agencies argues that students scored better on standardized tests when they were more active in art, compared to those who were less active in art. Those same students reportedly also watched less TV, felt less bored at school and participated in more hours of community service (National Assembly of State Arts Agencies 2006).

STEAM framework does not aim to replace, but rather to enhance STEM, by invoking a greater sense of creativity, and to encourage students who might not otherwise consider a STEM job to do that by adding a focus on art and integrating scientific and humanistic disciplines in a creative way. The objective is to teach kids that they do not have to be only analytical or only creative—they can be both.

Storytelling is one of the specific methodologies that can be used to apply STEAM framework in the field of education. Stories can be used to illustrate complex or abstract scientific concepts. According to Bruner (1986), "[Narrative] deals with human or human-like intention and action and the vicissitudes and consequences that mark their course. It strives to put its timeless miracles into the particulars of experience and to locate the experience in time and place." (Bruner 1986).

Stories can engage our thinking, emotions and imagination, and, as listeners, we engage in the story with both our body and mind. Storytelling is a human art form that teaches about the human experience. By telling stories, teachers can reach students in ways they cannot do with other scientifically bound strategies. In this way, teaching core school subjects like math and science can be done in a more student-oriented fashion and by using art as a medium of communication and sharing ideas (NYU 2020).

An even more recent development in the field of STEAM curriculum in education is digital storytelling. At its basic, digital storytelling consists of using information and communication technology (ITC) to tell stories. Other terms used to describe

similar techniques are: digital documentaries, computer-based narratives, digital essays, electronic memoirs, interactive storytelling, etc. All of these are using the art of telling stories through a variety of multimedia instruments, including graphics, audio, video and web publishing. Digital stories usually contain some mixture of computer-based images, text, recorded audio narration, video clips and/or music. Digital stories can vary in length, but most of the stories used in education typically last between 2 and 10 min. The topics used in digital storytelling range from personal tales to the recounting of historical events, exploring life in a community or other topics (University of Houston 2020).

Co-creation in teaching and learning, described by Ryan and Tilbury in 2013 as "a new pedagogical idea that emphasizes learner empowerment," was developed, similarly to STEM and STEAM, as a response to changes in education and the work marketplace—new expressed needs. This new approach focuses on the role of students (most of the times higher education students) in research, design and delivery of education (Bovill 2020).

In the current volume, the topic of art and science in education, the concepts of STEAM and co-creation in teaching and learning have been integrated with another innovative and context relevant concept: Responsible Research and Innovation (RRI) that constitutes both a framework and a checklist or standard in the field of educational (applicative) research and innovation.

Responsible Research and Innovation, originally described by Owen and Macnaghten (in 2012), is defined by the European Commission as: "an approach that anticipates and assesses potential implications and societal expectations with regard to research and innovation, with the aim to foster the design of inclusive and sustainable research and innovation" (European Commission 2020a). RRI promotes and implies the collaboration of different societal actors (researchers, policy makers, private sector representatives, educational community, civil society and citizens) throughout the entire research and innovation process, with the aim of aligning the research process and its consecutive outcomes with the needs, values and expectations of society.

According to a RRI dedicated FP7 funded program, RRI Tools (RRI Tools Consortium 2020), RRI framework comprises a set of four process dimensions and three categories of outcomes that research and innovation (R&I) processes should be aligned to, in order to be considered "responsible." In brief, the four process dimensions, recommended to be followed by any R&I process to be considered "responsible", are: (1) diversity and inclusiveness; (2) anticipation and reflectivity; (3) openness and transparency and (4) responsiveness and adaptiveness to change. The three categories of outcomes, essential for any R&I process to aim for or include, in order to be considered "responsible," are: (1) learning outcomes: including engaged publics and responsible actors and institutions, facilitating the achievement of R&I results; (2) R&I outcomes: assuming ethically acceptable, sustainable and socially desirable R&I outcomes, through transparent processes and continuous, meaningful deliberation to incorporate societal voices in R&I; (3) solutions to societal challenges: especially by searching for solutions to address the seven societal "Grand Challenges" formulated by the European Commission (European Commission 2020b).

The European Commission proposes a similar framework for defining and operationalizing RRI, comprised of six dimensions covering the importance of promoting: public engagement in R&I, gender equality, teaching of Science Education in schools, access of stakeholders throughout the R&I process, ethical conduct of research and the anticipation of societal implications of these processes (European Commission 2014).

If the birth of modern science is marked by the abandonment of "the principle of secrecy" (Rossi 1974) for which, since the seventeenth century, society is no more considered as an obstacle for the development of science, probably RRI framework celebrates a new era in which science and society may be strictly interconnected, valuing each other.

For both relationships—art and science and science and society—we can adopt different perspectives in order to underlie their closeness or distance. Relationships between elements that seem distinct can be variously described, recalling the metaphor of water and land proposed by Thomas (Feyerabend and Thomas 1989). According to this metaphor, if we want to demonstrate that land is substantially different from water, we can choose the image of rock in the sea, while if we want to demonstrate that land and water can complement each other and, in this mixture, develop the most amazing properties, we should deal with marshland, puddles and glaciers. The direction that we may envision for characterizing the relationships between art and science and between science and society is closer to the latter images of the metaphor.

References

Bovill C (2020) Co-creation in learning and teaching: the case for a whole-class approach in higher education. High Educ 79:1023–1037

Bruner J (1986) Actual minds, possible worlds. Harvard University Press, Cambridge

Cunnington M, Kantrowitz A, Susanne H et al (2014) Cultivating common ground: integrating standards-based visual arts, math and literacy in high poverty urban classrooms. J Learn Arts 10(1)

EBSCOpost (2017) The STEAMy relationship between art and science. https://www.ebsco.com/blogs/ebscopost/steamy-relationship-between-art-and-science#:~:text=Traditionally%2C%20art%20and%20science%20have,one%20has%20on%20the%20other.&text=A%20great%20deal%20of%20creativity,a%20product%20of)%20scientific%20knowledge. Accessed 30 Nov 2020

European Commission (2014) Responsible research and innovation. Europe's ability to respond to societal challenges. https://ec.europa.eu/research/swafs/pdf/pub_rri/KI0214595ENC.pdf. Accessed 30 Nov 2020

European Commission (2020a) Responsible research and innovation. https://ec.europa.eu/programmes/horizon2020/en/h2020-section/responsible-research-innovation. Accessed 30 Nov 2020

European Commission (2020b) Societal challenges. https://ec.europa.eu/programmes/horizon2020/en/h2020-section/societal-challenges. Accessed 30 Nov 2020

Feyerabend PK, Thomas C (1989) Arte e scienza. Armando editore

Huet V (2015) Literature review of art therapy-based interventions for work-related stress. Int J Art Ther 20(2):66–76

Inoa R, Weltsek G, Tabone C (2014) A study on the relationship between theater arts and student literacy and mathematics achievement. J Learn Arts 10(1)

Institute of Arts Integration and STEAM (2020) What is STEAM education? https://artsintegrat ion.com/what-is-steam-education-in-k-12-schools/. Accessed 30 Nov 2020

NYU (2020) Storytelling in teaching and learning. https://www.nyu.edu/faculty/teaching-and-learning-resources/strategies-for-teaching-with-tech/storytelling-teching-and-learning.html#:~:text=Storytelling%20is%20a%20human%20art%20form%20that%20teaches%20about%20the%20human%20experience.&text=Stories%20help%20teachers%20reach%20novices,a%20meaningful%20and%20connected%20way. Accessed 30 Nov 2020

Owen R, Macnaghten P, Stilgoe J (2012) Responsible research and innovation: from science in society to science for society, with society. Sci Public Policy 39(6):751–760

Radder LMD, Sturkenboom HI, van Nimwegen M et al (2017) Physical therapy and occupational therapy in Parkinson's disease. Int J Neurosci 127(10):930–943

Rastipisheh P, Taheri S, Maghsoudi A et al (2018) The effects of playing music during surgery on the performance of the surgical team: a systematic review on published studies. In: Proceedings of the 20th congress of the international ergonomics association (IEA 2018), pp 245–253

Richmond S (1984) The interaction of art and science. JSTOR 17(2):81–86

Rossi PL (1974) La rivoluzione scientifica: da Copernico a Newton. Loescher

RRI-Tools (2020) RRI in a nutshell. https://rri-tools.eu/about-rri. Accessed 30 Nov 2020

Ruppert SS (2006) Critical evidence. How the ARTS benefit student achievement. National Assembly of State Arts Agencies (NASAA). https://resource-cms.springernature.com/springer-cms/rest/v1/content/3322/data/v9. Accessed 30 Nov 2020

University of Calgary (2020) Education—STEM & STEAM education. https://library.ucagary.ca/c.php?g=255548#:~:text=STEAM%20is%20an%20educational%20approach,%2C%20persist%20in%20problem%2Dsolving. Accessed 30 Nov 2020

University of Houston (2020) What is digital storytelling? https://digitalstorytelling.coe.uh.edu/page.cfm?id=27&cid=27. Accessed 30 Nov 2020

Vestberg H (2018) Why we need both science and humanities for a Fourth Industrial Revolution education. World Economic Forum. https://www.weforum.org/agenda/2018/09/why-we-need-both-science-and-humanities-for-a-fourth-industrial-revolution-education/. Accessed 30 Nov 2020

Zhu L, Goyal Y (2018) Art and science. Intersections of art and science through time and paths forward. EMBO Rep 20:47061

Chapter 2
Heritage Education and Digital Storytelling: Enriching Students' Soft Skills, Citizenship and Participation in a RRI Perspective

Elisabetta Falchetti, Cristina Da Milano, and Maria Francesca Guida

Abstract This chapter presents a project of school-work alternating training, centered on Heritage Education, framed from a Responsible Research and Innovation perspective. The authors involved two Sardinian high-school classes in a program of valorization of the Monte Prama's statue heritage, through the creation and public diffusion of digital storytelling products. An in-depth qualitative evaluation revealed students' acquisition of new knowledge, values and interests; enhancement of creativity and communication competences; and enrichment of soft civic participatory and social skills.

Keywords Heritage Education · Citizenship · Participatory methodologies · Digital storytelling · School-work alternating training · Curriculum innovation

2.1 Introduction

Many European studies confirm the power of cultural heritage to improve the quality of citizens' lives. In the fundamental report "Cultural Heritage Counts for Europe," key findings show the impact and stimuli of cultural heritage on personal development, identity, employment, creativity and innovation, economic contribution, education and lifelong learning, social cohesion and cooperation.

Cultural heritage not only builds up knowledge and skills in the field of heritage itself, but also broadens horizons and contributes to the development of skills, from literacy to social competences (CHCFE 2015). Therefore, Heritage Education (HE)

E. Falchetti (✉) · C. Da Milano · M. F. Guida
ECCOM (European Centre for Cultural Organization and Management), Via Buonarroti, 30, 00185 Rome, Italy
e-mail: falchetti@eccom.it

C. Da Milano
e-mail: damilano@eccom.it

M. F. Guida
e-mail: guida@eccom.it

© The Author(s), under exclusive license to Springer Nature Switzerland AG 2021
P. Sandu et al. (eds.), *Co-creating in Schools Through Art and Science*,
SpringerBriefs in Research and Innovation Governance,
https://doi.org/10.1007/978-3-030-72690-4_2

has been introduced in the EU curricula to develop new and effective educational paths (EU Commission of Ministers 1998) to foster individual and collective identity and to build new inclusive, intercultural, sustainable EU societies.

HE implies a teaching approach focused on the cultural heritage, incorporating active and participative educational methods, cross-curricular styles, partnership between the fields of education, culture and professional/work environments; involving and including multiple stakeholders; employing the widest open/inclusive variety of modes of communication and expression; entailing civil ethic values and attitudes socially directed. All these features could give place to HE in the horizon of Responsible Research and Innovation (RRI) (EU Commission 2018; Owen et al. 2012). HE should be promoted in different school subjects, at all levels of education and in all types of teaching (EU Committee of Ministers 1998) and encouraged in order to introduce educational and curricular innovation.

This paper aims to present a project of school-work alternating training (AT) focused on HE, in which concepts and framework of RRI can be recognized.

2.2 The Project "We Are Mont'e Prama" and the Digital Storytelling Lab

The Mont'e Prama heritage currently includes some extraordinary statues restored from more than 5.000 sandstone fragments. These fragments were dug up from a pre- or Nuragic necropolis (approximately first millennium BC) and were rediscovered in the site called Mont'e Prama (Oristano, Sardinia). The statues—now exhibited in the Cagliari National Archeological Museum and the Cabras Museum, near Oristano— have an invaluable historic and artistic value, because of their uniqueness in the iconography of the whole Mediterranean area (see https://monteprama.it/).

Nevertheless, despite their cultural importance, they are too little renowned or appreciated even in Sardinia island. For this reason, the Regional Service for Cultural Goods launched a communication and marketing plan, adopted by several private professional organizations, among which ECCOM, the author's cultural association. A participative strategy has been proposed for this endeavor, involving many social actors (multi-professional and multidisciplinary approach): schools, museums, professional associations, cultural experts and researchers. The final goal has been the creation by high-school students of Digital Storytelling (DS) contents to be publicized and disseminated by common and digital media.

DS consists in short digital videos with texts, images/photographs, sounds/music and narrating voice (Lambert 2006). The DS is considered a reflexive, transformative, inclusive, educational practice; it produces a deep cognitive, emotional and social impact both for the storytellers and for the recipients, who are empathically involved in the narration. DS is relevant to teaching and learning and is increasingly introduced in school curricula both for promoting the disciplinary and digital learning and to build citizenship attitudes; finally to promote access and inclusion of disadvantaged

or potentially marginalized people (Da Milano and Falchetti 2014; EU Commission 2012; Wang and Hong 2010).

Therefore, two classes of the Cagliari high-school "G. Siotto Pintor" were involved in a several days laboratory for the creation of a DS product, within an Alternating Training (AT) period. This DS Lab was part of the Regional Communication Plan, but in the organizers' view, it was also a reproducible model of active school participation in a social project and innovation in educational paths, school curricula and AT and, finally, a potential format in the field of lifelong learning.

2.3 Methodology

In line with the active, engaging, participative approaches of the HE and RRI framework, we avoided transmissive styles and preferred Lab paths encouraging the students to express themselves creatively and to take part in planning and implementing this socio-cultural challenge.

Diverse participatory methodologies and learning approaches were used: focus groups, round tables, brainstorming, interviews, questionnaires; peer-to-peer learning and evaluation, cooperative planning, work in groups, project-based learning; storytelling; research "on the field"; research action; socio-emotional learning.

The commitment was high and implied a great responsibility that the students, after an initial perplexity, have assumed with pride and dedication. The Mont'e Prama heritage was something unknown and "strange" to the students participating in the project. Therefore, its discovery and interpretation needed specific knowledge, a direct observation/contact with the statues, but also teamwork and dialogue with experts and other professionals (not only school teachers). Moreover, the use of the narrative approach was unfamiliar to the students and the digital techniques outright unknown for all of them. In order to carry out their commitment, they needed to master the rules and languages of both the classic narration and DS.

Finally, the social orientation of this experience required a deep reflexivity and awareness in all phases of the process and in the choice of themes, interpretations, messages, languages and styles of communication.

The DS Lab total duration was 40 h, between February 22, 2018, and March 16, 2018, through: six classroom meetings, focused on working for the creation of the stories and their editing in school, one outside school hour and one in a computer laboratory in Cagliari, visits at the Cagliari and Cabras Archeological Museums and a survey at the Mont'e Prama archeological site.

The project was finalized on May 3, 2018, by an open day with the involvement of all the project actors and common citizens. Twenty-five students, girls and boys, took part in this project. Students, teachers, experts, professionals of narration, heritage interpretation and digital communication worked together during the meetings in classrooms and "in the field"; archeologists and museum educators were interviewed at the two Museums and the archeological site.

Individual and collective brainstorming and compilation of word clouds on the key themes facilitated the process of creating original stories about the Mont'e Prama statues. Brainstorming has been useful to bring out personal beliefs, ideas, emotions and aims and to design collective maps of thoughts. Innovative concepts and visions have been constructed by students about this heritage; values, ethical principles, metaphors and social meanings have enriched the students' narrations.

Since iconic representations have a deep communicative impact, a lot of pictures, illustrations, drawings, etc., were analyzed collectively (in a social "photo circle") before selecting the images to insert in DS. The verbal/script language has been particularly worked at following the recommendations for "creative writing" (perfect syntax and grammar, poetry, rhymes, onomatopoeic words, etc.). The texts utilized for DS have been created individually, by each student, but each text was then submitted and evaluated by all the students in the working group, in a social "story circle." Sounds and music have been chosen by the students in relation to their evocative, narrative and emotional impact.

2.4 The Quantifiable Outputs

Working in groups and with different actors, during all the project phases, has been a very constructive and appreciated strategy by the students, particularly during the "peer" evaluation of the stories and images. The reciprocal listening, support, help and appreciation and the critical evaluation represented essential moments from a social and educational point of view, for both students and the involved professionals ("We are a truly real team"). The freedom of expression and interpretation (rare in the daily school lessons) has been encouraged ("I appreciated particularly the personal, permissive, encouraging, unconventional approach"; "The DS Lab allowed me to gather my ideas, to set-up my goal, and to plan a project, according to my personal point of view"). Also, during the visits at the two Museums and at the archeological site, the students were allowed to explore autonomously the statues and ruins and to develop spontaneously their ideas, impressions, sensations and emotions, before the interviews with the archeologists and museum educators ("I liked the visit at the Cabras Archeological Museum and site, because […] we have imagined a personal autonomous story"; "I liked very much that, before we were allowed to explore alone, we got to listen to the explanation of the guides, so that we could compare and join our emotions and sensations to the explanations").

The final products consisted in 23 original digital stories created and edited by the students. Except one boy that interrupted the AT, all the other students completed their commitment (two girls worked in pair). Their DS products followed the guidelines of the DS Center of Berkley (CA) and of BBC (Capturing Wales), presented during the Lab, the two most appreciated and experimented models for more than ten years. In their DS (2 min long, max 200 words, pictures and music and the narrating voice of the author) the students expressed their points of view, emotions, memories, keeping

in mind the communication and social goals of their commitment and considering the dialogue with a hypothetical audience.

The students' stories were organized around both the folk vision of the statues (because of their large dimensions, the statues are locally called "The Mont'e Prama Giants") and the cultural vision ("The Mont'e Prama Heroes," as suggested by the archeologists). The stories' narrations fluctuated between reality and myths— talked about heroes and giants, but also about artisans or artists creators of the statues, warriors, common people of the Nuragic villages; they also talked about the possible ancient meanings and values of these statues and what they can still evoke in our times: respect, sense of belonging, continuity between past, present and future, universal and eternal messages and values and archetypes ("I was happy to create a story of the giants, because I liked them immediately; they gave me the sensation of belonging to a common culture and history"; "In my storytelling I talked about the place where the statues were discovered, the point of view of the creator/artisan and the immense astonishment that you can feel when you admire them"; "My storytelling is focused on the emotions of the heroes, but also the emotions I felt during these 40 h… I created a connection between past and the modernity"; "I talked about the physical impact produced by the contact with the statues: their strength, energy and their power to connect us with the past time").

The students' stories also described the emotion in finding one's own roots, memories and traditions and the awareness of the timeless values of these statues and their symbols ("I felt a deep sense of belonging to a past culture, however connected to my culture"; "The heroes conveyed to me values and emotions"; "… I got a sense of belonging from the first moment I arrived at Cabras, where I felt a deep bond with the territory. The statues were powerful and I had the impression to be little … but they looked at me as an outcome/fruit of their past lives").

2.5 Qualitative Evaluation: Methods and Results

The students' assignment was completed. Their results were appreciable, despite their inexperience, the limited work time and some technical limitations (e.g., inadequate PCs and software). When the project was launched, most of the students did not know the Mont'e Prama heritage and (except for two of them) nobody had visited those Museums.

Without any doubt, new learning abilities and interest about the project's subjects (the statues) were developed. Students' narrative and digital competences (oral, written, visual) certainly improved as well as literacy and communication, interpersonal social and civic competences; cultural expression and awareness; sense of initiative and entrepreneurship. Interviews with the teachers and experts confirmed the achievement of all these results.

In order to evaluate more deeply the impact of this experience, we administered individual questionnaires with open-ended questions (by phenomenographic evaluation; Micari et al. 2007) looking at: (1) changes in interests, knowledge, ideas, values

and attitudes; (2) students' opinions about their experience, projects' strength and weakness; (3) how they could utilize the new competences; (4) their suggestions to sensitize their colleagues/peers.

From the answers to the questionnaires, it resulted a general appreciation for the DS Lab, described as very interesting, pleasant and satisfying "despite the effort" ("… moments of debate, entertainment, learning"); well organized and providing not only digital competences ("… an opportunity rather singular to develop transversal skills, useful in different contexts"; "… having a high educational and training value and promoting the search of new expressive skills"; "very interesting and fascinating; it teaches us to open our eyes towards perspectives usually unconsidered and to observe and interpret details […] I'm discovering the why of everything…"). The Lab promoted a new vision of the Mont'e Prama heritage ("Now I look at the statues from a new, stimulating perspective") as well to the heritage and culture in general.

At the end of the project, all the students reported improvements in knowledge and interest toward the statues and changes in their values ("I would recommend this experience to all people, because it has been very interesting, but especially because I believe that to be in contact with the statues and to immerse yourself in the peaceful atmosphere of the archeological site is a unique experience"; "I've changed my ideas on the Mont'e Prama statues; I didn't think that these had so important stories to tell and that they could transmit a lot of messages and values").

The achievement of the educational goals of the project was confirmed by the students' ability to plan an awareness pathway for other people, as requested by the questionnaire, inspired by their own experience. All the students expressed their appreciation for the narration and its potential in the personal and social improvement and communication ("By the narration I've learned to interpret the surrounding world and to describe it with the right words, to share with other people images, impressions, emotions and sensations").

In order to assess the DS quality, we followed the evaluation models by the DS Center (Berkley, CA) that considers as indicators: aim, point of view, fundamental dramatic theme/question, pace of narration, style of the script and of the contents, voice, images (Matthews-De Natale 2008).

All students built sound, correct and involving narrations, rich of emotions and personal points of view. The DS styles were creative and varied (tale, dialogue, poem, rhyming verses, etc.); their words were polished and refined. The emotional aspect has been introduced and mastered with great awareness ("What struck me mainly was the stories' composition, where impressions, emotions, and experiences have been conciliated"). Some DS reflected the echo of the Museums' narrations, however creatively revised by the students. The narration pace was involving. The voices, despite students' lack of experience, were generally pleasant, expressive and engaging, like an acting ("I particularly took care of the subjects and the voice tone, in order to generate a sorrowful but solemn spirit"). Images, sounds and music were wisely used to enhance the empathic result and to highlight the character of the narrations. The aesthetic look of the pictures suffered from the inexperience of the photographers, but were anyway acceptable. DS created by the students have been

published on the website www.monteprama.it; they constitute an integral part of the Regional Communication Plan.

In students' opinion, the relationships with "other worlds" of professionals, experts, teachers, were enriching and stimulating for the introduction of new languages, perspectives and behaviors. After the first acquaintance, a sound relationship, confidence, spirit of collaboration, reciprocal interest and comprehension among all the participants were built. A continuous observation of the students' behaviors carried out by a researcher during all the project phases confirmed the positive group relationships and the students' ability to take part in constructive teamwork.

Finally, this experience seemed to have reinforced students' transversal and soft skills, scarcely cultivated in the traditional curricula but fundamental in a RRI approach. The students, in their questionnaires, claimed with satisfaction to have gained new relational and communication skills; autonomy and self-esteem; enthusiasm, self-motivation and awareness; social and cooperative skills, as working in group/different teams, building partnerships and involving other people; empathy; interests toward their communities; ability to plan and project management; sense of initiative in the realization of the assignment; information management and organizational skills; citizenship competences, such as recognizing and valorizing the local heritage as agent of social cohesion, identity and belonging; ethical attitudes, such as the responsibility toward preservation and use of the cultural heritage; esthetic competences allowing them to recognize the value of beauty, art, in all their shape and forms; critical thinking and other important attributes ("I didn't believe that this project would be so important and exciting for me and be able to stimulate not only the narrative aspect but also <<introspective aspects>> that now I want to deepen"; "The Lab was very involving and amazing. I learned to explore some aspects of myself that were unknown before. I felt well and very integrated… I've developed skills to express and reveal myself. I believe the Lab opened for me a new world in which I will throw myself in"; "I learned to consider a museum, an exhibition, or any other source of culture with different eyes"; "I'll remember forever the strong relationship and the trust developed with my classmates… I discovered their abilities, openness, collaboration and sympathy"; "My strongest emotion was when, looking at my video with my voice and music in the background, I've realized that what before seemed impossible to me, now, it was a reality…").

2.6 Final Considerations and Discussion

The favorable evaluation of the project by students, teachers and other participants and the achievement of the planned goals, the changes in students' ideas, interests, attitudes and knowledge, denoting a significant interiorized learning (as described by Ausubel et al. 1978), confirm the value of the themes and methodologies selected and of this innovative didactic approach.

Heritage Education (HE) appears as a new promising domain to generate basic, transversal and soft skills, new ways of building citizenship, democracy, inclusion and civic participation. It is worth to intensify research in the educational, training and lifelong learning domains, to explore the HE potential also from a RRI perspective.

In our project, the narration proved to be an effective, creative, inclusive, involving and educational way of communication; it favored student learning and reflective metacognitive processes; it promoted their multiple intelligences and improvement of their basic transversal soft competences. In our Lab, the storytelling played a fundamental role in the process of sensitization and motivation and in providing students with rich and different tips that they developed in various forms and messages.

Narration is more accessible and inclusive than formal languages (Bruner 2003) and can have a fundamental role for its power of stimulating sympathy, empathy and creativity of sharing ideas, visions, emotions and ethical principles.

Our conclusion is related to the opportunity to introduce more incisively the use of narration in school curricula, but also in the social communication and in the work environment.

From a RRI perspective, narration should be considered for its invaluable social communication innovative power. The creative use of the digital medium (perceived as an obstacle at the beginning of our Lab after the presentation of our aims) has been considered by the students as an amazing challenge and opportunity of personal development. Our experience confirms the educational value of the digital resources if utilized in creative, reflective and committing ways and not just as a medium for collecting data and information. In our opinion, DS should be taken in consideration among communication/expression practices fit to achieve RRI objectives.

Our experience also confirms the educational value of involving the students in "real projects," conducted to obtain specific products/outputs. The shift from the frequent school transmissive dynamic toward active and participative methodologies represented for our students a happy and fertile discovery, a decisive stimulus for activating motivation and responsibility. In the last years, many pedagogical recommendations invite educators to introduce in school curricula the socio-emotional learning, because it is more suitable to the personal and interpersonal problems of the young generations (Goleman and Senge 2014). Our Lab has facilitated the use of socio-emotional themes and approaches; the results and the participants' favorable comments confirm the success and the appreciation of this strategy.

In conclusion, this Lab seems to have activated RRI processes, led to students' "empowerment" and contributed to the development of the students' personality. Moreover, the empowerment processes have been "social": all the participants in this project have improved knowledge, vision, competences and shared the gratification for this work.

At this point, the social benefits of the project include mainly the project participants, but a wider impact is possible by the diffusion of the DS and by the capitalization of the professional and human growth that all the project actors feel to have gained.

References

Ausubel DP, Novak JD, Hanesian H (1978) The educational psychology: a cognitive view. Holt, Rinehart and Winston, New York

Bruner J (2003) Making stories. Harvard University Press

CHCFE Consortium Counts (Cultural Heritage for Europe) (2015) (Bertel-smann). ISBN 978-83-63463-27-4

Da Milano C, Falchetti E (2014) Stories for museums. Museums for stories. Vetrani Ed., Nepi (VT)

EU Commission (2018) Responsible research and innovation. Horizon 2020. https://ec.europa.eu/programmes/horizon2020/en/h2020-section/responsible-research-innovation

EU Commission, YEP4 Europe Team (2012) DiG Em project—lifelong learning program EACEA. https://www.yep4europe.eu/wp-content/uploads/2016/05/methodology_green_all-v22.pdf

EU Committee of Ministers Recommendation (98) 5 Concerning Heritage Education (1998) https://rm.coe.int/CoERMPublicCommonSearchServices/DisplayDCTMContent?documentId=09000016804f1ca1

Goleman D, Senge P (2014) The triple focus. A new approach to education. More Than Sound Ed.

Lambert J (2006) Digital storytelling: capturing lives creating community. Berkley Digital Diner Press

Matthews-De Natale G (2008) Digital storytelling tips and resources. Simons College, Boston. Eds-courses.ucds.edu/eds204/SU12/ELIO8167B.pdf

Micari M, Light G, Calkins S, Streitwieser B (2007) Assessment beyond performance. Phenomenography in educational evaluation. Am J Eval 28(4):458–476

Owen R, Macnaghten P, Stilgoe J (2012) Responsible research and innovation: from science in society to science for society and with society. Sci Public Policy 39(6):751–760

Wang S, Hong Z (2010) Enhancing Teaching and Learning with Digital Storytelling. Int J Inf Commun Technol Educ 6(2):76–87

Chapter 3
Community-Based Co-creation of Soft Skills for Digital Cultural Heritage, Arts and Humanities: The Crowddreaming Method

Nicola Barbuti, Annalisa Di Zanni, Paolo Russo, and Altheo Valentini

Abstract This chapter outlines the current state of advancement in the development of an innovative living laboratory methodology, the *Art of Crowddreaming*, co-designed and implemented within the interdisciplinary network activities of the Digital Cultural Heritage, Arts and Humanities School (DiCultHer) network of over 70 Italian organizations. The methodology is illustrated by two case studies: *Quintana 4D*, engaging schools of all grades from the city of Foligno to design, expand and manage the Museater of the Joust of Quintana, and *Heritellers*, engaging high-school students of classical studies from the city of Trani in the making of "CastleTrApp," a digital storytelling app and a Museater performance about the Swabian Castle in this city. The methodology engaged innovators, researchers, school students of all grades and other societal actors as a community in the challenge to invent, co-design and build prototypes of cross-generational digital monuments.

Keywords Crowddreaming · Museater · Quintana 4D · Heritellers · DiCultHer

N. Barbuti (✉)
Department of Humanities (DISUM), University of Bari Aldo Moro, Bari, Italy
e-mail: nicola.barbuti@uniba.it

A. Di Zanni
Liceo Statale Classico, Linguistico e Scienze Umane "F. De Sanctis", Bari, Italy
e-mail: annalisa.dizanni@unifg.it

P. Russo
Stati Generali dell'Innovazione, Rome, Italy
e-mail: paolo.russo@statigeneralinnovazione.it

A. Valentini
Egina S.r.l., Foligno, Italy
e-mail: altheovalentini@egina.eu

© The Author(s), under exclusive license to Springer Nature Switzerland AG 2021
P. Sandu et al. (eds.), *Co-creating in Schools Through Art and Science*,
SpringerBriefs in Research and Innovation Governance,
https://doi.org/10.1007/978-3-030-72690-4_3

3.1 Introduction

The basic principles of what would later become the *Art of Crowddreaming* living laboratory method (Chesbrough 2003; Almirall and Wareham 2011; Pallot 2009; Ståhlbröst 2012; Alcotra Innovazione 2013; Travaglini and Sabella 2016) were tested successfully for the first time in 2014 in the USA, by one of the authors who planned and managed the launch of the "Treasures and Tales" art exhibition in Wilmington, DE as a local community effort (Guardia di Finanza Italiana 2014).

In 2015, such principles began to be tested in Italy too within the DiCultHer network, as guidelines to plan a school contest titled "Crowddreaming: youth co-create digital culture." Since then, three editions of the contest were organized, reaching out to over 5000 students and leading to the creation of a small community of teachers.[1]

Given the positive feedback coming from the contests, several members of the DiCultHer network decided to run a recursive prototyping process to transform a successful practice into a living laboratory methodology, largely inspired by the principles of MIT's *Theory U* (Scharmer 2000, 2018). The two case studies presented in this paper are the first iterations of this process.

The methodology design is in continuous development as it provides tentative answers to three ever-changing Digital Age challenges to teaching and developing cultural heritage and heritage-related skills: the challenge of speed, of form and of persistency.

The *Challenge of Speed* has been common to most aspects of technology-driven societies since the twentieth century. Change is so fast and relentless that often it is no longer possible to weigh-in on extrapolations of past patterns in order to analyze trends in planning processes for an uncertain future. Therefore, new social technologies are developed to help people learn from the future as it emerges. *Theory U* has proven itself a very effective tool in this regard. This theory proposes to face the *Challenge of Speed* through a recursive prototyping process, based on a phase of deep listening of the needs of a social ecosystem, understanding of one's own role in the change process and then development of a prototype to drive the change. Nonetheless, *Theory U* is designed for leading communities or enterprises, so it is not very easy for teachers and students to connect with its language and tools. The challenge is to find a way to make the very effective *Theory U* concepts and tools accessible to educators, cultural operators and kids.

The *Challenge of Form* is relevant to digital societies. Humankind learned to shape energy into meaningful information only a few decades ago. It was a first in the history of humans, and the extent of this revolution has yet to be explored and understood. Digital technologies advance very fast, and new "energy-shaping" skills to be learned emerge at a very hard-to-keep-with pace. Even the concept itself of "digital" has yet to be clarified. Very often, it is still regarded as a concept situated beyond the physical dimension, where things happen almost by magic. The challenge

[1] https://www.diculther.it/crowddreaming2018/.

is to find a way to help teachers, cultural operators and kids to acquire the correct digital mindset and skills in a sustainable way.

The *Challenge of Persistency* is specifically relevant to the digital cultural heritage. A construct with a tangible mass tends to be permanent and persistent in time. Moreover, it is well known how to preserve it. Energy-based digital constructs are very volatile. Millennials are the first generations called to face the challenge of persistency because their culture is and will be more and more digital. The challenge is to find a way to help them pass their digital cultural heritage to the next generations. It also requires finding solutions to transmit digital knowledge, practices and art through the centuries.

Starting from this state of the art, the Digital Cultural Heritage, Arts and Humanities School—DiCultHer,[2] an interdisciplinary network of over 70 Italian organizations including universities, research entities, cultural institutions and associations, co-designed and developed the innovative living laboratory methodology *The Art of Crowddreaming* that proved to be able to engage innovators, researchers, students of all grades and other societal actors as a community in the challenge to invent, co-design and build prototypes of cross-generational digital monuments.

Such a challenge fosters the activation of several key competences described in the lifelong learning European framework (European Commission 2018): digital competence; personal, social and learning competence; civic competence; cultural awareness and expression competence. It also addresses the Responsible Research and Innovation (RRI) public engagement key theme.

3.2 The Art of Crowddreaming Methodology

The *Art of Crowddreaming* methodology relies upon a profound belief: any kind of mind can be called intelligent only if it is capable of dreaming. This is also true for the connective minds of the digital age. The *Art of Crowddreaming* is the discipline that trains a connective intelligence to develop/experience a lucid dream. A *crowddream* comes to life usually as an individual insight that becomes a clear intent by the means of interacting with that individual's social circles. Then, it becomes a compelling story about a desirable future that can capture the imagination of a crowd big enough to make it happen. Finally, it evolves into a well-designed innovation project that can shape the shared dream into a reality.

There are three critical transitions in the *crowddreaming* process: from insight to intent, from intent to compelling story and from compelling story to responsible innovation project.

The first transition corresponds to the deep listening phase on the left side of a U procedure, and it can be facilitated by the tools and methods suggested by the *Theory U*.

[2]https://www.diculther.it/.

The second and third transitions are placed on the right wing of the U, where a prototype must be created. The *Art of Crowddreaming* facilitates this process by using methods and language of Hollywood blockbuster productions instead of the academic leadership-oriented vocabulary of *Theory U*. Such a narrative choice makes the concept more accessible to everyone and the prototyping phase way more appealing to students: they are fascinated by the idea of learning how to produce a blockbuster movie.

The starting point is an obvious statement: every project that achieved its goal has a success story to tell. Proceeding backwards from the socially desirable future of the happy ending, innovators, researchers and societal actors co-create the plot with all of its characters, relationships, places, props (resources), events and subplots that had to be there.

Dramatic theory and movie production science provide highly professional and perfectly shaped tools to develop a story from the original insight to its final staging in the real world as required by the *crowddreaming* process. Not only do they force "producers" to identify all the necessary human, financial, material and time resources, but they also oblige them to explore the emotional, ethical and human dimensions, which are often overlooked within the purely analytical and numerical approaches of project management.

"Crowddreaming a Digital Monument" is a framework that facilitates the set-up of an art-of-crowddreaming-based living laboratory experience focused on the development of the soft skills required to co-create, manage, preserve and safeguard the digital cultural heritage. The monument is a *museater* (technical.ly, 2014), a place to preserve digital memories about cultural exchanges and at the same time a stage where people are encouraged to act and interact.

Based on the constructivist approach of project-based learning, teachers, students and societal actors are challenged to *crowddream* a digital story about a relevant topic regarding their cultural identity. The story must be able to travel in time to many future generations. The overall goal is to encourage both teachers and young people to get ready to face the epochal challenge to which the new generations are called: they are the first ones in the history of humankind to find themselves passing on a purely digital cultural heritage.

3.3 The Quintana 4D Museater Labs Success Story

It is harder and harder for young people to find their own place in well-established social contexts in Italy. Their digital-oriented culture does not fit very well with traditions.

Starting from the above insights, the "Q4D Museater Labs" project was developed by some community leaders from the Italian city of Foligno, in Umbria. Here, the local social life revolves around the 70-year-old tradition of the "Giostra della Quintana." The Quintana was born in 1946 as an ahead-of-its-time social innovation experiment. The town had to recover from the deep wounds of the civil war

and the re-enactment of a historical joust held in 1613 was the perfect theme for a city-wide event that could help people to forget contemporary political conflicts. Cultural heritage belongs to everyone. That innovative experiment worked so well that it became a tradition. Today, the whole city is committed all-year round in the planning and delivery of two two-week events, in June and September, filled with Baroque-age-inspired cultural shows, contests, a wonderful historical parade and, of course, the thrilling and very competitive final Joust.

Kids and teenagers love to be part of this celebration: working at the baroque taverns until late is their first "adventure" out of the family, in a very safe and community-controlled environment. It is an eagerly awaited rite of passage. Nonetheless, the community is facing a new challenge nowadays: Young people in their late teens or early twenties are leaving the Quintana community at an unprecedented rate. In the not-so-long run, the very survival of the tradition is at stake. The radically different nature of the Millennials' digital culture is the main reason of such disaffection. Although the Quintana evolved with the society during its 70-year long history, interviews showed that young people do not feel that is still the case because they are not even able to start a conversation with "Elders" in charge about adapting the celebrations to the digital age. They feel there is not—and there will not be—space to make the Quintana an expression of their own digital culture.

According to the three critical transitions in the *crowddreaming* methodology, first informal meetings and structured coaching circles helped the community leaders to develop a clear intent:

- transforming digitalization from a threat into an opportunity to engage young people in new and different ways into these celebrations that are the very heart of the community
- creating new jobs for young people placed at the crossroad between digital technologies and local fascinating and rich cultural heritage.

Public meetings were organized by key local stakeholders and schools to share the general vision about bringing a museater to Foligno.

A "museater" is an institution that cares for (conserves) a collection of stories (story world) of scientific, artistic, cultural or historical importance, helps people to experience them in contexts where their educational and emotional impact is maximized and facilitates their re-use and dissemination. In simpler words, it is a hybrid between a museum, a theater and a digital research laboratory or "Shakespeare meeting augmented reality." As the Bard wrote: "All World's a stage." Augmented reality technologies can make it true. They reveal and make accessible an energy-based digital space surrounding the physical space where we are used to walk. This space is still empty and waits for someone to transform it into a place where humankind can live a part of its life.

Young people were dared to take this empty digital space over and to make it as beautiful and significant as their ancestors made its "physical" counterpart. They were called to *crowddream* and build an invisible city on top of the visible one. A generational pact was signed: young people are in charge of this digital dimension

of reality. The elder people will help the younger generation as they can to build this virtual place.

This vision took some time to be shared (by all people involved), but it eventually engaged a group of Millennials. Brainstorming meetings guided by a facilitator helped them to create the success story of their "dream" museum about Quintana. The process found its catalyst in the young woman who is now in charge of the Q4D Museater Labs. She quite literally dreamed and designed her own new (and first) digital cultural heritage-based job. She acted as a tutor for apprenticeship programs with high schools, focused on project-based learning, where students helped professionals in the process of planning the production of their success story and making the Labs a reality.

Today, the Q4D Museater Labs is hosted at the beautiful Brunetti-Candiotti baroque palace. A new job of coordinator was created and assigned to a 27-year-old woman. A committed and ever-growing group of over 600 Millennials has been working as volunteers to "populate" Foligno's streets and buildings with geo-located digital ghosts. Moreover, the augmented reality (AR)-enhanced experimental exhibition has become both the focus for educational activities of almost every school in Foligno and a destination for occasional visitors and guided tours with over 1500 visitors in the first 9 months of its life. Institutions like Ente Giostra della Quintana (the managing organization for the celebrations and the joust), the City of Foligno and the Centro Studi Foligno support the project strongly because they can see the commitment of kids and teens. Professionals offer free time to help them out of good will and because they can see the potential for future business. It is already a small win-win ecosystem, where young people feels that they do not need to find a place in the society: They can build it by exploring and shaping the digital dimension of their city.

The quantitative and qualitative Key Performance Indicators (KPIs) used to assess the advancement of the project were: jobs created, young people actively engaged in activities, stakeholders involved in supporting the activities and Museater's visitors. At the time this paper is drafted, it is still too early to observe a significant variation in the drop-off indicator, but the engagement indicators let us assume that the impact will be positive in this regard.

3.4 The Castle Trap Success Story

The Heritellers project initial insight comes from the awareness of the unexploited cultural and touristic potential of the Swabian Castles of Trani, one of the most important monuments built by Frederick II. Because of its location and history, the cultural value of Frederick II monuments in all of Apulian land is obvious for all the people in that land; particularly, the kids appreciate the several proofs of his love for this region.

In the Heritellers project, the students developed another type of Museater Lab by undertaking a number of initiatives (animated visits, recreational–didactic activities,

creation of digital audio–video storytelling and swipe stories, etc.) that transformed the school in a civic center. There, they could design together with and for the territory activities that developed the citizenship in the name of an inclusive identity paradigm. Therefore, the intents of the project were:

- to promote a sense of cultural ownership;
- to provide students with a global vision of all aspects of cultural heritage (research, protection, management, use, production), fostering an approach oriented to communication and enhancement and opening up to the use of digital technologies for promoting and sharing the cultural heritage.

"Heritellers" name is in fact formed by merging the two key words for the project: heritage and storytelling, to indicate that the students are the leading actors of the project, the true storytellers of heritage.

Students were challenged to imagine the story of developing a successful app with the goal to showcase Frederick II cultural innovations, guiding the visitors to discover the true significance of the Swabian Castle. From there, they were asked to plan all the activities required to create the success story of their museater. Following the living lab methodology, they were asked to test their assumptions on the field, by undertaking the initiatives above mentioned.

The activities performed in the first year aimed at the discovery and learning about the Swabian Castle of Trani's centuries of history. Starting with the goal to discover and showcase the monument, the Heritellers project produced a *swipe story*, a digital multimedia storytelling product developed on an illustrated tape, animated and interactive on multiple levels, that uses a simple and immediate language based on drawings, images, words, games, sounds and movies. With this storytelling entirely resulted from co-creativity, knowledge and skills of students, a process of "cultural ownership" started that made the students both aware and responsible custodians of cultural heritage inherited from the past and innovative creators of contemporary and future digital cultural heritage. The swipe story was entitled "CastleTrAPP," and it was produced in Italian and English. It tells the most important phases of the Swabian Castle history and can be downloaded from Google Play and App Store.

By retracing some of the transformations occurred over the centuries (the Frederician foundation, the sixteenth-century fortification, the transformation into nineteenth-century prison), the app allows the visit of the Swabian Castle of Trani using tools of digital storytelling. In a simple and funny way, a very large audience can explore the castle, personalizing its experience with using the app, thanks to the different levels of depth of the proposed content, all scientifically validated.

Consistent with the theme of the project, as part of the event "Live a wonderful adventure at the Swabian Castle of Trani" organized by the "De Sanctis" high-school in 2017 and 2018, 31 high-school students involved about 340 children of "Roncalli" primary school of Altamura in the development of an animated and playful visit of the castle (with a duration of 20–25 min for each group of children). This led to the discovery of the monument as it was reproduced in the storytelling co-created for the app.

At the entrance, each group of children was welcomed by some students, costumed or not, who gave everyone a schematic plan of the castle, on which the places that could be visited were indicated and named. Guiding the children to the so-called Frederick II Room, the designers of the app briefly explained them the project, with the help of drawings and a presentation projected on a big screen. Other student's guides explained to children the mechanism of the game, prompting them to imagine going back in time and finding themselves in the Middle Ages lost in the castle as the two protagonists of the app. At a given signal, during the journey, the children had to close their eyes; by reopening them, they would find themselves in a different historical phase, conceptualized and designed by the high-school students in a museater way. Since that moment, children were gradually guided along a path that went through a series of significant environments in the architectural, functional and symbolic history of the monument, meeting rooms equipped with medieval furniture and populated by some costumed characters who really lived in the castle and were reproduced in the swipe story of the app:

- In Frederick II room, a banquet was held with dishes and foods typical of a medieval meal and a background medieval music was arranged;
- In the central courtyard, the architect Cinardo, builder of the castle, showed the children the figurative shelves of Frederick age, explaining their symbolic meaning;
- In the western courtyard, the children, through a digital effect, came across the legendary ghost of Armida and some workers at work;
- In the central courtyard, a jailer showed the children the transformations suffered by the castle and finally guided them to the exit;
- In the entrance hall, the children were invited to comment their experience and were given a souvenir bookmark, personalized with the two protagonists of the app.

Several other events were carried out within the project, involving students and children: a conference, two more projects of alternating school job on digital technologies applied to the enhancement of cultural heritage, a workshop on digital archeology and digital libraries and archives.

On October 8, 2017, the students took part in the F@MU Family Day at Trani National Museum, planning and carrying out recreational and educational activities for families visiting the Swabian Castle of Trani also by using CastleTrAPP, about 120 persons during the day.

The CastleTrAPP was promoted in the International Week of History during a study day dedicated to the teaching of history, cultural heritage and landscape, October 23, Trani Museum Centre, where several cultural heritage and digital humanities experts participated.

About the same number of visitors was involved in the White Night of the Classical High-Schools that was organized with the active partnership of territorial stakeholders. The goal was to test the replicability of the project: in the first year, participants were the Puglia Museum Centre (Ministry of Cultural Heritage and Activities), the Carabinieri Command for the Protection of Cultural Heritage, Lega Navale di

Trani and the company Swipe Story Ltd; in the second year, collaborations with the first-year partners continued, plus the University of Bari Aldo Moro Department of Humanities and the Centro Studi Città di Foligno.

Finally, by presenting CastleTrAPP and the Heritellers Project, the "De Sanctis" students won the fourth provincial prize of the National Plan for Digital Education (PNSD).

Heritellers project realized another small win-win ecosystem, where young people felt that they do not mandatorily have to find their place in society from a young age; they can build their place by exploring and shaping the cultural and digital dimension of their city.

The quantitative and qualitative Key Performance Indicators (KPIs) used to assess the advancement of the project are the same as those used for evaluation of Quintana 4D project: job opportunities created, young people actively engaged in activities, stakeholders involved in supporting activities and Museater's visitors. At the time this paper was written, it was too early to evaluate the drop-off indicator, but the engagement indicators let the authors assume that the impact would be positive.

3.5 Conclusion

This paper outlines the key principles of the "Art of Crowddreaming", a living laboratory methodology that was elaborated for the first time in 2014 in the USA. A crowddream comes to life usually as an individual insight that becomes a clear intent by the means of interacting with his/her social circles. It becomes then a compelling story about a desirable future that could capture the imagination of a big enough crowd so to make it happen. Finally, it evolves into a well-designed innovation project that can shape the shared dream into reality. This methodology was proven to be able to engage innovators, researchers, schools of any grade and other societal actors as a community in the challenge to invent, co-design and build prototypes of cross-generational digital monuments.

The "Art of Crowddreaming" is strongly oriented toward public engagement and is designed to stimulate the development of some of the key competences described in the lifelong learning European framework: digital competence; personal, social and learning competences; civic competence; cultural awareness and expression competence. Its innovative component resides mainly in its intent to ensure a broader impact of the *Theory U* by making its key practices and concepts more accessible to educators, youth workers, teenagers and kids and by using familiar and engaging tools borrowed from movies industry rather than the original quite philosophical and academic language.

The two case studies show that this living laboratory methodology works, and it is adaptable to very different scales: from a single school class to a whole community. The common trait of these living labs is that they are already small ecosystems, where young people do not feel that they need to find a place in the current society,

but that they can build their own place, by exploring and shaping the digital cultural dimension of their city.

Further observations and evaluations are required to verify whether the very positive results of short-term engagement will transform into long-term positive changes.

References

Alcotra Innovazione (2013) La creazione di Living Lab Transfrontalieri
Almirall E, Wareham J (2011) Living labs: arbiters of mid- and ground-level innovation. Technol Anal Strateg Manag 23(1):87–102
Audiovisual Living Lab Terrassa [Spagna]. www.alivinglab.com/alten
Chesbrough HW (2003) Open innovation: the new imperative for creating and profiting from technology. Harvard Business School Press, Boston
Design Creative Living Lab [Francia]. www.citedudesign.com/fr/home/
European Commission (2018) Proposal for a council recommendation on key competences for lifelong learning 2018/008
European Network of Living Labs. www.openlivinglabs.eu/
Guardia di Finanza (2014) Treasures and tales of Italy's Guardia di Finanza art recovery team. DeBooks
http://quintana4d.it
https://itunes.apple.com/it/app/castletrapp/id1296811891?mt=8
https://play.google.com/store/apps/details?id=com.ia2.castleTrAPP
https://technical.ly/delaware/2014/10/09/special-exhibit-wilmington-offers- italian-art-seen-apps/
https://www.diculther.it/
https://www.diculther.it/crowddreaming2018/
InnovaLab [Spagna]. blog.innovalab.org/
Pallot M (2009) Engaging users into research and innovation: the living lab approach as a user centred open innovation ecosystem. Webergence Blog. Copia archiviata, su cwe-projects.eu. URL consultato il 7 giugno 2011 (archiviato dall'url originale il 9 maggio 2012)
Regione Piemonte. Idee per la progettazione dei Living Lab sul territorio della regione Piemonte
Scharmer CO (2000) Presencing: learning from the future as it emerges. Presented at the conference on knowledge and innovation, 25–26 May 2000, Helsinki School of Economics, Finland, and the MIT Sloan School of Management, OSG, 20 Oct 2000
Scharmer CO (2018) The essential of Theory U: core principles and applications. Berrett-Koehler Publishers
Ståhlbröst MH (2012) The living lab methodology handbook. Centre for Distance-Spanning Technology, Sweden
Travaglini F, Sabella P (2016) Scuola 4.0, living labs: le scuole che progettano il futuro. https://www.zonalocale.it/2016/11/30/scuola-40-living-labs-le-scuole-che-progettano-il-futuro/23394?e=sansalvo

Chapter 4
Open Science Hub-Portugal: Toward Community Development, Innovation, and Well-Being Through Open Schooling

Maria Inês Vicente, Ana Isabel Faustino, Paulo Jorge Lourenço, Ana Peso, José Varela, Carlos Martins, Filipe Pinto, and Pedro Russo

Abstract Open Science Hub (OSHub) is an international network, with several European partners, aimed at creating collaborative learning spaces based on Responsible Research and Innovation (RRI) principles; supporting communities that traditionally do not engage with Science, Technology, Engineering, Arts and Mathematics (STEAM) due to social, economic or geographical barriers to make science-informed decisions and tackling locally relevant STEAM-related challenges. OSHub-Portugal has been working closely with the local school community in the co-development of educational strategies grounded on RRI and Open Schooling principles. This innovative participatory approach promotes the development of student-led projects based on community needs and fosters collaboration with stakeholders, transforming schools into agents of community well-being, innovation and development.

Keywords Collaborative learning · STEAM · Community · Open schooling

4.1 Introduction

The societal challenges of the twenty-first century require the ability to integrate the knowledge and expertise of different societal actors, using more innovative, efficient and open methodologies. Moreover, as stated in the Cape Town Declaration (6th Science Centre World Congress 2011) signed at the Science Centre World Congress in 2011, public opinions on science and technology should be "heard and incorporated into decision-making processes," claiming the need for citizens to have a better understanding of science and technology, to be able to actively participate in science-informed decision-making.

M. I. Vicente (✉) · A. I. Faustino · P. J. Lourenço · A. Peso · J. Varela · C. Martins · F. Pinto
Open Science Hub-Portugal, Municipality of Figueira de Castelo Rodrigo, Portugal
e-mail: maria@plataforma.edu.pt

M. I. Vicente · P. Russo
Astronomy & Society Group, Leiden Observatory and Dep. Science Communication and Society, Leiden University, Leiden, The Netherlands

P. Sandu et al. (eds.), *Co-creating in Schools Through Art and Science*,
SpringerBriefs in Research and Innovation Governance,
https://doi.org/10.1007/978-3-030-72690-4_4

27

However, the 2013 Eurobarometer on Responsible Research and Innovation (Eden 2014) showed that the majority of European citizens, despite feeling that research and innovation should incorporate public dialogue, do not feel adequately informed about the science and technology topics of the day. In addition, evidence shows that Science, Technology, Engineering, Arts and Mathematics (STEAM) activities within informal science education institutions, such as museums or science centers, are not enough socially inclusive (Dawson 2014). Participants to STEAM activities disproportionately originate from the more affluent, middle-class backgrounds and ethnically dominant backgrounds of society (such as white European backgrounds in the case of Europe), in addition to groups that live in urban areas and participate in these activities as part of a school or family group.

This renders the urgent need to build new capacities and to develop innovative, meaningful and inclusive ways of connecting science, schools, enterprises, civil society, governments and the community in general. Science centers and museums now have a concrete opportunity to become platforms for scientific citizenship, contributing to a steady improvement of science literacy and awareness and supporting communities with tools and networks to participate in discussions and decisions that affect science and politics.

This need and motivation are in accordance with the Responsible Research and Innovation (RRI) policy agenda that seeks to:

- connect different aspects of the relationship between R&I and society (public engagement, open access, gender equality, science education, ethics and governance)
- engage all relevant actors (researchers, policy-makers, educators, innovators, civil society) in all stages of R&I processes and governance in order to act as a catalyst towards *an open science and innovation system that tackles the societal challenges of our world* (www.rri-tools.eu).

The Open Science Hub (OSHub) network was developed exactly with this aim: to create community spaces—OSHubs-based on a RRI approach to science education and community participation. In these spaces, *STEAM education would be an essential component of a learning continuum for all, from pre-school to actively engaged citizenship* (Hazelkorn et al. 2015), and the involvement of all societal actors would be the key to build stronger links between knowledge and skills. Very importantly, OSHubs creation is planned in the communities that traditionally do not engage with STEAM due to various barriers—geographical location, socio-economic status or minority ethnic group background—for engaging and supporting these communities to tackle locally relevant STEAM-related challenges.

The OSHub network is coordinated by Leiden University (the Netherlands), with partners in Portugal, Spain, the Netherlands and Ireland. OSHub-Portugal (OSHub-PT; Plataforma de Ciência Aberta in Portuguese—www.plataforma.edu.pt) was inaugurated in July 2017 and is the first hub of this network, in a partnership between Leiden University and the Municipality of Figueira de Castelo Rodrigo (FCR). The mission of this hub is to bring together science, technology and innovation into the daily life of local and regional communities. The hub is located in

the village of Barca D'Alva, a municipality of FCR, in the northeast interior of Portugal and at the border with Spain (Province of Salamanca), with a population density of 12.31 inhabitants/km^2. The population of this region (on both sides of the border) has limited access to STEAM-related initiatives, and the importance of community development of this border was identified by the EU program Interreg V-A—Spain-Portugal (POCTEP).

One of the central problems identified in inland communities, particularly in border and low-density areas—as it is the case of FCR—was the distance from important areas of development in the fields of science, technology and innovation, associated with a high rate of school failure, demotivation and dropout, low innovation and reduced capacity for investment and entrepreneurship and lack of collaboration among entities from the region (Conselho Local de Ação Social 2011). In particular, in 2001, around 70% of the population of FCR had school qualifications corresponding to middle class or lower, the illiteracy rate was of 15.5% (16.2% in 1991; Agrupamento de Escolas de Figueira de Castelo Rodrigo 2017), and the school dropout rate was of 28.2% (CIM Beiras e Serra da Estrela 2015). Also, in 2016/2017, the school group of FCR was in the 401st position in a total of 626 schools in the national ranking at the high-school level (with an average grade of 9.88 out of 20). This persistent scenario has been associated with a high turnover and instability of the teaching staff and parents' lack of involvement and responsibility in the educational process (Conselho Local de Ação Social 2011). Moreover, a general gap was identified, in terms of effective collaborations between the school community and the reality of the territory, namely the local community, civil society and the professional environment.

This emphasizes the need of promoting relevant learning environments that foster collaborations, providing opportunities for learners to understand and to question their role in society and to make vital contributions to their communities. This aligns with the views of the Open Schooling framework, according to which *schools, in cooperation with other stakeholders, become agents of community well-being* (European Commission 2017), building innovative ecosystems, where school projects meet the real needs of the community, *for which leaders, teachers, students and the local community share responsibility, over which they share authority, and from which they all benefit through (…) the development of responsible citizenship* (Sotiriou and Cherouvis 2017).

Considering the scenario above, we defined as the main objectives of OSHub-PT to promote school performance and to boost entrepreneurship and social innovation, while establishing collaborations between different stakeholders from the region. These efforts follow the RRI principles and strategy, in particular the Open Schooling framework, and are grounded on three main axes:

Axis I | Participation and Community: to increase the involvement of and co-creation within the community in STEAM-related topics and initiatives, focused on locally relevant issues, linked to the sustainable development goals (SDGs), contributing to the development of more informed, critical thinkers and active citizens.

OSHub-PT outreach strategy incorporates three complementary elements, linked by a common topic: (1) a temporary exhibition focused on a topic of both local relevance and global impact, for the general public (e.g., the current exhibition is about climate change and its impact on the daily life of local communities: "Conversations with the Earth: Indigenous Voices on Climate Change"); (2) a transdisciplinary educational program targeted at the school public (3–18 years old) and families, based on the topic of the exhibition and grounded on Inquiry-Based Science Education (IBSE) and citizen science projects; and (3) participatory public events, also based on the topic of the exhibition, for the general public, e.g., science cafes, hackathons, scenario workshops or participatory labs.

In the context of the educational program, participants are challenged to reflect, through learning opportunities in science and technology, about the impact of their daily habits and decisions in the surrounding world—e.g., the use of car versus less polluting alternatives, recycling and plastic reduction, consumption habits, like food choices and water usage—and, by participating in citizen science projects, will be closely involved with the scientific process and researchers, while contributing to build knowledge and value about the region. Moreover, the participatory public events promote open discussion and public participation on topics of local relevance, by bringing together a multitude of perspectives and experiences from different societal actors around a common challenge.

Axis II | Schools as Community Hubs: to support schools in adopting sustainable Open Schooling approaches, positioning them as collaboration hubs for community well-being, development and innovation.

OSHub-PT is supporting local schools in co-creating innovative and collaborative curricula/programmes, grounded on locally relevant issues that link to the SDGs, with defined learning outcomes, providing meaningful STEAM learning experiences based on real-life projects and multi-stakeholder collaboration.

Importantly, to ensure sustainability, OSHub-PT is working directly with school boards, facilitating the integration of Open Schooling approaches in the school organizational culture; also, continuing professional development for the school community, namely for teachers and school boards, is being organized.

During the beginning of the 2018–2019 school year, OSHub-PT collaborated with the local schools, for the integration of Open Schooling approaches both in formal and non-formal settings, based on challenges identified as relevant by students and teachers (e.g., waste management at school and pregnancy in adolescence), by using evidence-informed approaches and by involving the local community.

Axis III | Social Innovation: to boost social innovation projects through opportunities in science and technology, while promoting the collaboration among different entities from the region.

OSHub has been working as a facilitating agent in the community, promoting open, inclusive and interdisciplinary processes in which citizens and community groups collaborate with researchers, professionals from enterprises and policy-makers to tackle community-defined problems at local and regional levels, using a community-based participatory research approach.

As an example, a project with a local environmental non-governmental organization (Associação Transumância e Natureza) has been co-developed, that arose from a need to promote science communication in nature reserves, namely among the tourist and school public, and at the same time provided the opportunity for the creation of scientific knowledge via citizen science approaches. In this regard, a participatory approach was employed throughout the different steps of the development process: from conceptualization (through an immersive three-day workshop that was organized with relevant stakeholders—experts in tech development, designers, nature reserve managers, researchers, tourism operators, school community—to define the paper prototype of the content and tools to be developed) to development and implementation (through the involvement of schools and the community in general in the prototyping phase by participating in several educational activities using these tools).

After 14 months of existence, OSHub-PT has served more than 3000 participants via exhibitions, science workshops for students, activities for the general public (workshops, talks, science cafes), national school interchange events, conferences for specialists, citizen science projects, Open Schooling projects, project residencies with researchers and innovators and collaborative innovation projects.

These activities are being developed in the context of local relevant challenges (currently, the focus is on climate change) and are the result of multiple collaborations with universities/research groups, companies and civil society organizations, with around 20 collaborations already successfully established. Furthermore, OSHub-PT co-developed a citizen science digital application that was awarded with an international grant (is a partner in the H2020 EU-Citizen Science Project) and benefited from national and international recognition.

In the following section, we will focus on the strategy being developed in the context of Axis II | Schools as community hubs, in particular on the Open Schooling approach and corresponding assessment tools.

4.1.1 Schools as Collaboration Hubs for Community Development, Innovation and Well-Being

As mentioned above, the schools from FCR faced a scenario characterized by high students' dropout rate and low performance, high turnover and instability of the teaching staff, lack of involvement and responsibility of parents in the educational process and disengagement of the school community with the reality of the territory and community.

Overcoming such a multidimensional challenging scenario requires a cooperative effort between several societal actors, focused on relevant challenges and real-world problems, with schools becoming hubs of collaboration in their communities. In addition, it is fundamental for this process to be embedded in a global framework that allows a systematic assessment and sharing of resources and best practices across different schools and communities.

The H2020 project Open Schools for Open Societies (OSOS) provided this type of global framework, where schools were supported to make vital contributions in their communities, through the co-creation of student-led projects that met real needs and drew upon local expertise and experience. This framework was based on the following pillars: (1) promoting collaboration with non-formal and informal education providers, enterprises and civil society; (2) supporting schools to become agents of community well-being; (3) promoting partnerships that foster expertise, networking, sharing and applying science and technology research findings and (4) bringing real-life projects to the classroom, all these while focusing on (5) effective parental engagement (Sotiriou and Cherouvis 2017).

Considering that the OSOS project provided a suitable framework given the challenges identified in the school community of FCR, we developed an educational strategy, in collaboration with the local school group, grounded and integrated in the principles of this framework. Throughout this process, OSHub-PT supported teachers and school boards in several activities, namely co-development and implementation of curricula; selection and application of the assessment tools based on best practices; documenting the process and the resulting practices; facilitating the dialogue with community stakeholders; ensuring a continuous training program for teachers and school boards.

This pilot project was implemented during the 2018–2019 school year, both in formal and non-formal settings, along two main avenues:

(1) In the formal setting, the work was conducted in the context of the school subject of "Citizenship and Development," in four classes from the 5th (two classes) and 7th grades (two classes). Through the co-development of curricula, in collaboration with teachers, psychologists and the school board, we aimed at developing student-led projects with relevance and impact in the community and grounded on collaborations with several societal actors (research institutes, industry, enterprises, municipalities, civil society and community at large, namely families).

This strategy followed the approach established by the OSOS project, consisting of four steps that guide the design and development of the process: FEEL—observation and listing of the issues in the community; IMAGINE—interaction with societal agents in the community to identify points of intervention and solutions; CREATE—development and implementation of an action plan that includes a resource list, budget and timeline; and SHARE—dissemination of the project in order to inform and motivate others to conduct their own projects. The implementation of this strategy in the classroom is following the plan described in Table 4.1.

(2) In the non-formal setting, OSHub-PT developed, in coordination with teachers, a STEAM learning space for open collaboration at the local school—Open Schooling Club. This activity was extracurricular (1 afternoon per week), engaging groups of students from the 5th to the 9th grade and involving a total of 40 students. This club was dedicated to the co-creation of student- and teacher-driven projects, based on IBSE, citizen science and maker-centered

Table 4.1 Open schooling plan in the context of the "Education for Citizenship and Development" subject*

Step	Description
1	Students form working groups, by considering gender equality and interculturalism principles while reflecting about the reality of their communities
2–5	FEEL: Students make a self-assessment of opportunities and challenges in their communities and discuss them in groups and with the entire class. This assessment is extended to extracurricular exercises, in collaboration with families. Each group selects a locally relevant challenge that they would like to tackle throughout the school year
6	Each group then presents the selected challenge to the entire group of a given school year, and a common challenge is selected per school year, through participation, debate and vote
7–8	IMAGINE: Students develop, in groups, possible strategies to tackle the selected challenge and identify relevant stakeholders. In the end, a subset of strategies (depending on the number of groups) is selected per class through participation, debate and vote
9	Students meet with the identified relevant stakeholders to propose and discuss the planned strategies
10	Students present the challenges and respective strategies to the whole school community
11–21	CREATE: Students develop their projects in collaboration with the identified relevant stakeholders
22	Students present their projects to the whole school community
6–28	SHARE: Students share their projects through selected media (social media, newspapers, brochures and leaflets) and community events
End	An inter-school summit is organized where students present their projects and experiences to neighboring schools and new schools commit themselves to implement Open Schooling strategies in the following year

*Each class has an average duration of 50 min

projects and activities. It encouraged the intersection between the programmatic curriculum and local relevant issues and needs and partnerships with local and regional stakeholders—with whom OSHub-PT has already developed and implemented several initiatives in a successful collaborative process.

The driving themes of the Open Schooling Club were selected by teachers in a participatory event, organized at the beginning of the school year, for the entire teacher community of the school group. The selected themes for the respective school year were waste and sustainability; biological agriculture; biodiversity and local environmental challenges.

By implementing Open Schooling approaches, we aimed to position the school community as a collaboration hub for tackling local relevant issues. Specifically, we expected to positively impact the students in terms of capacity of inquiry and

twenty-first century skills (namely critical thinking and problem solving, collaboration, communication and creativity), motivation, interest, deeper learning competences (teamwork, active citizenship and gender equality) and ultimately school performance (grades, assiduity and school dropout).

For that, the variables shown in Table 4.2 will be assessed systematically, by using the framework developed by the OSOS project (Sotiriou et al. 2017a, b). In addition, for the assessment of twenty-first century skills, the tools developed in the context of the project Promoting Innovative Learning Approaches for the Teaching of Natural Sciences (PLATON), co-funded by Erasmus + Program will be used.

School performance, in particular grades, assiduity and school dropout will be assessed using the tools regularly used by schools, to make a systematic and longitudinal comparison among classes and school years. Furthermore, the educational process and practices will be documented using the templates from the RRI tools project that support the design of RRI-oriented educational practices, providing an opportunity for these practices to be shareable, reviewable and re-usable (Jiménez and Pinzi 2016).

Finally, in the context of OSOS tools, the degree of school organizational change will be assessed, for the implementation of Open Schooling approaches. By working directly with school boards, the envisioned outcomes are that schools will embed Open Schooling approaches in their organizational culture.

To guarantee sustainability, continuing professional development for teachers and school boards is organized, based on Open Schooling and RRI framework and tools (the first one happened in the beginning of the 2018–2019 school year, the following being scheduled for 2nd and 3rd terms), in order to provide teachers and school principals/administrators with confidence, knowledge and experience to properly implement these methodologies. Moreover, to promote networking with local stakeholders, the training sessions' program will include workshops with local associations, industries and enterprises, facilitating dialogue, the creation of collaborative projects and a closer contact with the reality of the community.

4.2 Discussion

OSHub proposes a model of community hubs for responsible citizenship through an RRI approach to science education and community participation. At the core of the OSHub strategy is the Open Schooling framework, where student-led projects meet the real needs of the community and promote collaboration with relevant stakeholders, transforming schools into agents of community well-being, innovation and development.

Preliminary data showed that one of the biggest obstacles in implementing Open Schooling approaches in the formal setting is the difficulty of combining school curricula and the development of projects focused on real-life challenges. This is related to the weak relationship between schools, local communities and societal challenges, the lack of policies incentivizing and rewarding the formal adoption

Table 4.2 Assessment of Open Schooling approaches

Indicators	Tools	Target audience
From OSOS		
Holistic school approach and vision	Open school development plan	School community
Effective introduction of RRI principles in the school operation	Self-reflection tool	
	Web analytics	
Effective and sustainable partnerships with external stakeholders	Open school development plan	School community
	Questionnaire on effective and sustainable partnerships	
	Questionnaire for assessing the community and cultural conditions	
	Focus groups and interviews	Teachers/school heads and external stakeholders
	Web analytics	School community
Educational resources generated in school settings according to the local needs	Web analytics	School community
	Open school development plan	
Increased interest and motivation	Questionnaires – Science motivation questionnaire II – Intrinsic motivation inventory – State emotions – Cognitive load	Students
Development of key skills	Web analytics	School community
	Problem solving competence tool	Students
Focused policy support actions	Focus groups and interviews	Teachers/school heads and external stakeholders
From PLATON		
Inquiry-based learning twenty-first century skills: creativity; critical thinking and problem solving; communication; collaboration	Assessment of the twenty-first century skills	Teachers
	Assessing student progress template	
	Teacher inquiry and assessment planning templates	
	Student inquiry organizer	Students
From RRITools		

(continued)

Table 4.2 (continued)

Indicators	Tools	Target audience
RRI integration	Self-reflection tool	School community, external stakeholders
	Self-reflection exercises for educators	Educators
Support a reflection and revision of the practices and the opportunity to be shareable and re-usable	Templates to design RRI-oriented educational practices	
From school educational system		
Grades	Tests and exams	Students
Assiduity	Class assiduity and punctuality	
School dropout	Standard measures of school dropout	

and implementation of Open Schooling approaches and the low level of confidence and experience of teachers in applying these less traditional methodologies in the classroom.

An effective strategy requires both bottom-up and top-down approaches to simultaneously: promote the development of curricula that engages students in conducting relevant projects in their communities, in collaboration with several societal agents; provide continuous professional training to teachers and school principals/administrators; allow teachers to share and collaboratively review their practices, from regional to international level; incentivize school boards for implementing and integrating Open Schooling approaches in the organizational structure of their schools. In addition, based on the evidence being collected using the assessment tools specified in Table 4.2, OSHub is working closely with policy-makers to demonstrate and advocate for the importance of education through Open Schooling.

Finally, it will also be important to devise strategies that formally involve societal agents in the revision of school curricula and of the institutional structure of schools. Some of these strategies can include creating multi-stakeholder school advisory boards, composed of researchers, professionals from industry and enterprises, representatives of civil society and parents' associations or decision-makers; or strengthening the cooperation between schools and the professional world through the development of career programs, thus providing the opportunity for direct engagement with experts from different sectors and for training in real-world contexts. Moreover, providing training for teachers early on, by embedding Open Schooling approaches in the curricula of education universities, could also return promising outputs.

Going back to the beginning, facing the challenges of our contemporary society, science centers and museums have the responsibility of developing innovative, meaningful and inclusive ways of connecting science, schools, enterprises and society.

This has been the goal of OSHub-PT since day zero by providing structural support and an interface for direct collaboration between schools, families, researchers, entrepreneurs and civil society.

We believe that a model like this will empower communities with the necessary tools and skills to tackle relevant societal challenges in a sustainable manner, thus contributing to their development, innovation and well-being.

Acknowledgements Open Science Hub-Portugal is funded by the Municipality of Figueira de Castelo Rodrigo in collaboration with Leiden University, the Netherlands. It also receives funding from the H2020 SciShops.eu project (grant agreement no. 741657).

References

6th Science Centre World Congress (2011) Cape Town Declaration. Retrieved from http://media. fssc.se/2014/06/Cape_Town_Declaration.pdf

Agrupamento de Escolas de Figueira de Castelo Rodrigo (2017) Projeto Educativo 2015-2019. Retrieved from http://www.aefcr.pt/moodle/mod/resource/view.php?id=1693

CIM Beiras e Serra da Estrela (2015) Pacto para a Desenvolvimento e Coesão Territorial da Comunidade Intermunicipal das Beiras e Serra da Estrela. Retrieved from http://cimbse.pt/wp-content/uploads/2015/10/Pacto_31agosto2015BSE_completo1.pdf

Conselho Local de Ação Social (2011) Diagnóstico Social de Figueira de Castelo Rodrigo. Retrieved from https://cm-fcr.pt/wp-content/uploads/2014/09/Diag_Social.pdf

Dawson E (2014) "Not designed for us": how informal science learning environments socially exclude low-income, minority ethnic groups. Sci Educ 98(6):981–1008

Eden G (2014) Special Eurobarometer 401: survey summary on responsible research and innovation, science and technology. J Responsib Innov 1(1):129–132. Retrieved from https://ec.europa.eu/commfrontoffice/publicopinion/archives/ebs/ebs_401_en.pdf

European Commission (2017) Horizon 2020 science with and for society, Swafs-01-2018-2019 Open schooling and collaboration on science education. Retrieved from http://ec.europa.eu/research/participants/portal/desktop/en/opportunities/h2020/topics/swafs-01-2018-2019.html

Hazelkorn E, Ryan C, Beernaert Y et al (2015) Science education for responsible citizenship report. European Commission. Retrieved from https://ec.europa.eu/research/swafs/pdf/pub_science_education/KI-NA-26-893-EN-N.pdf

Jiménez IM, Pinzi V (2016) RRI in practice for schools: handbook for teachers. In: RRI tools, Horizon 2020 framework programme of the European Union. Retrieved from https://www.fosteropenscience.eu/sites/default/files/pdf/4333.pdf

Sotiriou S, Cherouvis S (2017) D2.1 open schooling model. In: Open schools for open societies, Horizon 2020 framework programme of the European Union. Retrieved from https://cordis.europa.eu/project/id/741572/results

Sotiriou M, Mordan C, Murphy P et al (2017a) D6.1 OSOS assessment methodology. In: Open schools for open societies, Horizon 2020 framework programme of the European Union. Retrieved from https://cordis.europa.eu/project/id/741572/results

Sotiriou M, Koukovinis A, Mordan C et al (2017b) D6.2 OSOS impact assessment tools. In: Open schools for open societies, Horizon 2020 framework programme of the European Union. Retrieved from https://cordis.europa.eu/project/id/741572/results

Chapter 5
Constructing Scientific Notions: Students' and Teachers' Conceptual Change Through a Responsible Research and Innovation Initiative

Zacharoula Smyrnaiou, Eleni Georgakopoulou, Menelaos Sotiriou, and Sofoklis Sotiriou

Abstract This chapter explores how the Responsible Research and Innovation (RRI) principles, in combination with school community conceptual change, can promote a different perspective of knowledge. Our research question focused on how RRI principles can support teachers and students to change their cognitive frames through the concept of "learning science through theatre." Theatrical performances were organized by school students (N = 2500) during 3 school years (from 2014 to 2017), embedding scientific concepts, creative and art techniques and cultural/social elements. We analyzed teachers' and students' representations, employing both quantitative and qualitative methods. Results revealed students' need to disentangle conceptual aspects of explanation and the need to create a network of knowledge and collaboration with respect to the RRI principles.

Keywords Scientific notion · Conceptual understanding · Cognitive schemes · Responsible Research and Innovation

5.1 Introduction

According to recent research, when teachers and students try to acquire a scientific notion, a conceptual change is made (Tsvetkov 2014). Semiotic systems can offer the appropriate ground to examine students' cognition, and the coexistence of multiple cognitive systems (Vergnaud 2009; Smyrnaiou et al. 2017a, b) can help researchers to understand the mechanisms of cognition.

Z. Smyrnaiou (✉) · E. Georgakopoulou
National and Kapodistrian University of Athens Ilissia, Athens, Greece
e-mail: zsmyrnaiou@eds.uoa.gr

M. Sotiriou
Science View, Athens, Greece

S. Sotiriou
Ellinogermaniki Agogi, Pallini, Greece

© The Author(s), under exclusive license to Springer Nature Switzerland AG 2021
P. Sandu et al. (eds.), *Co-creating in Schools Through Art and Science*,
SpringerBriefs in Research and Innovation Governance,
https://doi.org/10.1007/978-3-030-72690-4_5

5.2 The Role of Representation and Cognitive Schemes and Frames

Students' conception is a constantly evolving system. "Representational systems" include systems of spoken and written symbols, static figural models or pictures, manipulative models and real-world situations. The content is specific, but not limited. Tsvetkov (2014) broke down this cognitive procedure into three categories: perception, processing and representation.

Nehring et al. (2017) categorized cognitive procedure by the categories of integration, organization, selection and reproduction. The physical world consists of matter and energy, and the abstract world consists of information and intelligence (Wang 2015). Moreover, Yao (2009) tries to connect external notions and the internal representation of students by describing the information processing triangle with the angles of abstract, brain and machines. Theoretically, concepts are not initially shaped but gradually enriched during the learning process. The organization of knowledge is achieved through the frames that are used to lead to the hyperlinks of knowledge (cognitive context, emotional context, socio-cultural context).

5.3 The Responsible Research and Innovation Principles

The Responsible Research and Innovation (RRI) principles in the education context can be very beneficial for students, as they support their critical thinking and collaborative learning skills, while establishing multidisciplinary and stronger student engagement.

The RRI framework promotes a transparent process where innovators need to be mutually responsive. In the field of education this can lead to an open classroom and an innovative system of learning that tackles societal challenges. However, parallel to the large positive impact on human welfare and well-being, science and technology sometimes create new risks and ethical dilemmas. RRI involves society in discussing how science and technology can help create the kind of world and society of the future. The principles of RRI, according to Groves (2017), are:

1. Governance: addresses the responsibility of policymakers to prevent harmful or unethical developments in research and innovation. Policymakers change their politics to cope with new and unexpected challenges.
2. Public engagement: implies that societal challenges should be framed on the basis of widely representative social, economic and ethical concerns and on common principles like the strength of joint participation of all societal actors—researchers, industry, education community, policymakers and civil society—in decision-making processes.
3. Gender equality: addresses the underrepresentation of women, indicating that human resources management must be modernized and that the gender dimension should be integrated in the research and innovation content.

4. Science education: faces the challenge to better equip future researchers and other societal actors with the necessary knowledge to fully participate and take responsibility in the research and innovation processes.
5. Open access: states that research conducted considering RRI must be both transparent and freely accessible, with no fees required.
6. Ethics: implies respect for fundamental rights and the highest ethical standards, to ensure increased societal relevance and acceptability of research and innovation outcomes.
7. Sustainability: RRI indicators contribute to sustainable growth, as scientific knowledge functions as an ecosystem influencing well-being.
8. Social justice: refers to (a) the relationship between researchers and research subjects and (b) the participation of different social groups in sharing benefits arising from research.

5.4 RRI Principles in the "CREATIONS" Project

CREATIONS project aimed to develop a framework emerged from the main principles of Responsible Research and Innovation and to support large research infrastructures in optimizing their organizational policies, to better manage the important outreach outcomes and to maximize social/economic impacts of research.

The project tried to promote learner engagement, the share of results, access to scientific archives and innovative activities for all. Educational activities using creativity and empowering students to actively engage in the learning process were promoted. The project improved scientific skills and supported creativity as an element in the processual and communicative aspects of pedagogy by integrating culture and art and proposing innovative teaching strategies. In addition, CREATIONS aimed to demonstrate how unique research infrastructures, like the European Organization for Nuclear Research (CERN), could act as a catalyst in the development of innovative science education. Such large scientific organizations could act as incubators for innovative ideas, which—due to the open and democratic culture of the organizations—could develop solutions for major societal challenges.

The CREATIONS project framework presented how innovative and creative educational methods and tools could be used to incubate this culture into science class setting. Community engagement is particularly important in terms of the societal level of the Responsible Research and Innovation. Empowerment and agency by the means of dialogue based, individual, collaborative and community activities for change, ethics and trusteeship were other CREATIONS project principles that resonated with the responsible research and innovation concept. Another crucial mission of the program was to promote gender equality in research and technology.

5.5 Case Study: The "Learning Science Through Theater" Project as an Example of the Connection of CREATIONS Project to the RRI Principles

The learning science through theatre (LSTT) initiative was a large-scale project implemented in Greece (https://www.lstt.eu/), based on the pedagogical framework developed by the European project CREAT-IT (https://creatit-project.eu/). LSST continued to be implemented in the framework of the European project CREATIONS (https://creations-project.eu/). It followed the principles of the Science Education Declaration of effective and efficient research and aimed at enhancing creativity in the classroom (https://www.opendiscoveryspace.eu/community/culture-creativity-curiosity-413201) in the context of Science, Technology, Engineering, Arts, Mathematics (STEAM) classes.

During LSST, students engaged in activities such as writing scientific stories (scenarios), composing music, designing sets, costumes and coming up with choreographies. The methodology of learning science through theater is integrating creativity, art and science education fulfilling the RRI principles. The aim was to foster a conceptual change in school managers, teachers and students.

5.6 Methodology

5.6.1 Participants

In the timeframe 2014–2017, about 150 theatrical performances were produced and presented to diverse audiences, over 2500 students were engaged, and over 200 teachers from different domains cooperated with each other. This specific paper will present the results of the first 3 years. Due to the large sample size (national level) and given that, while this manuscript is being drafted, the research is still in progress, only few scientific notions referred to the procedure of shaping cognitive schemes were included in this paper.

5.6.2 Methods

The research used a participatory approach. A research protocol and adjacent tools were used to ensure the validity of the process. Researchers contacted teachers every week throughout the project duration to ensure the proper use of its scientific and pedagogical frameworks.

Two formal workshops were organized, at the beginning and in the middle of the process. The researchers presented the main principles of the project to the members

of the school community and to the school training coordinators, school counselors, school directors and teachers.

Researchers visited the schools three times: at the beginning, in the middle and at the end of the program, before the final event and the presentations of students' theatrical performances. Some researchers acted as external observers taking notes of the process of student rehearsals, while other researchers, teachers and stakeholders acted as facilitators. As a result, researchers, schools and the local community participated in the program.

The evaluation methodology constitutes a mix of qualitative and quantitative methods that can lead to more insightful results. Also, content analysis was used and also the grounded theory that enables the production of a theory from the data systematically obtained and analyzed. The specific methods used were (a) observers–researchers' notes, (b) interviews with experts (teachers and school directors) and students and (c) pre- and post-evaluation tests and questionnaires. Researchers, teachers and students participated in the evaluation procedure.

The evaluation focused on: (a) the main learning approaches, such as inquiry-based principles, challenge-based and problem-solving approaches, multiple representational systems, cognitive and meta-cognitive approaches to learning, (b) the students' competences, such as cognitive, meta-cognitive, transversal hard and soft competences, research, creative, socio-emotional, collaborative, communicative and citizenship skills and (c) the integration of the RRI Principles.

Pre- and post-evaluation tests and questionnaires were given to teachers at the beginning and at the end of the project so that researchers could verify if teachers registered students' conceptual change and if they started to use RRI tools in their educational approaches. Pre- and post-tests consisted of 13 questions; questions 1–7 were based on the pedagogical framework of the CREATIONS research program, and questions 8–13 were related to the main principles of RRI. The focus of this paper was to investigate how teachers *used* each of the six RRI key aspects (governance, public engagement, gender equality, science education, open access, ethics) in the development and employment of the theatrical performances.

5.6.3 Results

Inquiry-based learning and pedagogical theories about stimulating students' motivation and creativity are known to Greek teachers. However, RRI principles are new in the Greek educational system, so most of the teachers are not familiar with them. Therefore, teachers' beliefs about RRI aspects were a great point of research interest. Given that RRI principles were an unexplored area for teachers, we expected to observe a big difference comparing pre- and post-questionnaires.

The results are presented in Fig. 5.1 and in Appendix based on the answers of 140 teachers to the pre-questionnaire and of 144 teachers to the post-questionnaire. The questionnaires aimed to measure if teachers included the main principles of RRI in the preparation and the final presentation of the theatrical performances, how RRI

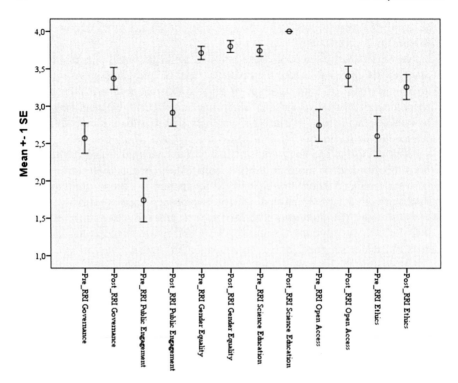

Fig. 5.1 Use of RRI key aspects pre- and post-intervention

key aspects were expressed during the whole procedure to what extent they used RRI factors (0: no use, 1: minimum use, 2: sometimes, 3: enough, 4: intensively) and, finally, if teachers, students and the whole school community had started to act and think differently about science.

Figure 5.1 shows an increase of the use of RRI key principles as a result of their participation in the program. Teachers, and the school community in general, did not use RRI key aspects before the LSTT program, but they got more familiar with them after the program. According to the results, the LSTT initiative helped incorporating the main RRI principles, and teachers started to learn and include them in their school reality.

Dependent samples *t* test showed that there is a statistically significant difference for pairs from 8 to 13, except for Pair 10 (see Appendix).

Science Education (Question 11) was the main aim of the program. Almost all of the teachers mentioned that the students learned how to negotiate with scientific notions. The results showed that students did not only learn "by doing," but also increased their cognitive load and science capital perspective. In most of the cases, a scientific theory and its connection to theatre constituted the initial starting point for writing the script. Students were interested in numerous scientific notions, such

as eco-systems, the structure of molecules and DNA, electricity, Newton's laws, chemical reactions, F functions and Pythagoras' theorem.

Both the students and the whole school community participating in the program collaborated in harmony with each other: different types of communities were created during the process; schools collaborated with local industries and research centers; teachers from different subject domains exchanged their ideas; local industries supported theatrical performances (Question 9—Public engagement).

It is also worth mentioning that a political change in the educational design started, as school stakeholders, like school counselors, had the opportunity to collaborate with education institutions through their training during the workshops. Typical examples of participating citizens are professionals like artists, stage designers and photographers, local services and organizations, the local press where students advertised their performances and parents who also got involved in the process. The Institute for Educational Policy and Municipalities also supported school theatrical performances.

During the whole process, the education community had to interact and collaborate with other actors, for example parents and local industries, in order to get some advice (such as theatre actors and directors), to advertise their theatrical performances and to find additional help for their activities (such as realizing their costumes and the music for the performance). Students promoted citizen science and open innovation, while scientific subjects were linked to other subject domains and all of them worked together to achieve a common goal. Students cooperated with their teachers and were provided with open access to research centers in order to use up-to-date science information and to communicate with researchers. As far as open access is concerned (Question 12), it is worth mentioning that the school community had access to replays, regardless of any economic difficulty.

School became the central actor, which guided as many actors as possible to achieve a common goal. All the educational, cognitive, scientific and entertaining principles were taken into consideration throughout the program (Question 13—Ethics). The discussion of ethical issues is in accordance with shaping cognitive schemes. More precisely, some of the issues discussed, as students' new ideas were born, were: (a) human anxieties about the role of time and future evolutions, (b) the role of women in science and their equal access to it, (c) environmental awareness, (d) the concept of interaction and cooperation between nations, (e) the role of scientific thinking in research and (f) the development of science for peaceful or military purposes.

Gender equality was a crucial issue too (Question 10). One of the main principles of the program was to promote the equal participation of boys and girls. Questionnaires indicated that an equal number of boys and girls participated in the program, while some teachers mentioned that lots of girls got interested in science; these results are in line with the project approach toward fostering the participation of both boys and girls, working collaboratively as a team.

Governance factor (Question 8) was also considered, as lots of teachers mentioned that school directors helped them throughout the process. Lots of school counsellors participated in the workshops for teachers' training and education. The project resulted in scientific and social progress in the way stakeholders, teachers

and students deal with a variety of issues and promoted changes in the way the school community manages science education. Governance has been considered as students actively interacted with researchers and research centers in order to foster and mainstream responsible research and innovation in the learning environments.

Participation in workshops and conferences, as well as visits to research centers, brought together all the cognitive subjects, serving what we call "universal design of learning" (Meo 2008). The factor sustainability and social justice has not been measured yet as RRI tools are still new in teachers' consciousness; therefore, these are going to be measured independently.

5.7 Conclusion

Teachers' responses to all RRI questions were greatly improved after participation in the LSTT program, except for gender equality, given that the majority of the schools had already taken into consideration the equal participation of boys and girls, from the beginning of the project.

The LSTT program was able to establish a culture of scientific thinking and to promote a deep conceptual change in policymakers and stakeholders, educational institutions and school communities. Teachers and students dealt with scientific notions in a creative way. The main aim of the pre- and post-questionnaires was to help researchers analyze if the LSTT program served the incorporation of the main principles of RRI and if teachers could include these aspects in their educational daily work.

Teachers embedded the main principles of RRI in the preparation and the final presentation of the theatrical performances and, with the students and the whole school community, started to act and think differently about science. As expected, given that RRI key aspects were an unexplored area for teachers, LSTT initiative proved to help teachers to introduce RRI aspects into school reality. RRI aspects can introduce a new way of thinking in the school community, teachers can get more familiar to new ideas, and students can acquire new skills and increase their interest in Science.

Appendix: Dependent Sample *t* test for Questions 8–13

Compared pairs		Pre-post mean difference	Std. deviation	t	p
Pair 8	Pre_RRI Governance–Post_RRI Governance	−0.800	0.632	−7.483	0.000

(continued)

(continued)

Compared pairs		Pre-post mean difference	Std. deviation	t	p
Pair 9	Pre_RRI Public Engagement–Post_RRI Public Engagement	−1.171	0.923	−7.508	0.000
Pair 10	Pre_RRI Gender Equality–Post_RRI Gender Equality	−0.086	0.284	−1.785	0.083
Pair 11	Pre_RRI Science Education–Post_RRI Science Education	−0.257	0.443	−3.431	0.002
Pair 12	Pre_RRI Open Access–Post_RRI Open Access	−0.657	0.639	−6.083	0.000
Pair 13	Pre_RRI Ethics–Post_RRI Ethics	−0.657	0.725	−5.360	0.000

References

Groves C (2017) Review of RRI tools project. J Responsible Innov 4(3):371–374. https://doi.org/10.1080/23299460.2017.1359482. http://www.rri-tools.eu

Meo G (2008) Curriculum planning for all learners: applying universal design for learning (UDL) to a high school reading comprehension program. Prev Sch Fail 52(2):21–30

Nehring A, Päßler A, Tiemann R (2017) The complexity of teacher questions in chemistry classrooms: an empirical analysis on the basis of two competence models. Int J Sci Math Educ 15(2):233–250

The Directorate-General for Research and Innovation of the European Commission (2012) Responsible research and innovation—Europe's ability to respond to societal challenges

Smyrnaiou Z, Georgakopoulou E, Sotiriou M, Sotiriou S (2017a) The learning science through theatre initiative in the context of responsible research and innovation. J Syst Cybern Inform (JSCI) 15(5):14–22. https://www.iiisci.org/journal/sci/Contents.asp?var=&Previous=ISS1705

Smyrnaiou Z, Sotiriou M, Sotiriou S, Georgakopoulou E (2017b) Multi-semiotic systems in STEMS: embodied learning and analogical reasoning through a grounded-theory approach in theatrical performances. WSEAS Trans Adv Eng Educ 14:99–114

Tsvetkov VY (2014) Cognitive information models. Life Sci J 11(4):468–471

Vergnaud G (2009) The theory of conceptual fields. Hum Dev 52(2):83–94

Wang Y (2015) Formal cognitive models of data, information, knowledge, and intelligence. WSEAS Trans Comput 14:770–781

Yao Y (2009) Interpreting concept learning in cognitive informatics and granular computing. IEEE Trans Syst Man Cybern Part B (Cybern) 39(4):855–866

Chapter 6
Women and Science: Outlook from an Italian School Competition

Ilaria Di Tullio and Lucio Pisacane

Abstract This chapter presents the results from a high-school competition fostering students' critical reflections on women's roles in science. The competition was organized in the framework of the GENERA European project and the first "Gender in Physics" day of the National Research Council of Italy (CNR) and the Italian National Institute for Nuclear Physics (INFN). One hundred twenty Italian high schools and more than 830 students produced tales, reports and videos about gender equality in scientific careers and women's roles in the physics disciplines. An ex-post questionnaire explored how participating students perceive the "women-science" association. This chapter presents students' views on gender equality in science along with an analytical tool developed to explore learner-generated contents. It proposes a tool for analyzing students' products, in collaboration with school teachers, to raise awareness and sensitize students regarding Responsible Research and Innovation topics.

Keywords Learners generated contents · School competition · Women in science

6.1 Introduction

This paper presents, in the framework of the GENERA European Horizon 2020, the results and the lessons learned from a high-school competition fostering the critical reflections of students regarding women's roles in science and proposes a useful tool to analyze digital learner-generated contents (Kearney 2011). The school competition stemmed from a collaboration between the National Research Council of Italy (CNR) and the Italian National Institute for Nuclear Physics (INFN), aiming

I. Di Tullio (✉) · L. Pisacane
Institute for Research on Population and Social Policies, National Research Council, Rome, Italy
e-mail: ilaria.ditullio@irpps.cnr.it

L. Pisacane
e-mail: lucio.pisacane@irpps.cnr.it

to improve female participation in science, starting from the high-school educational level.

The study aimed to:

- investigate how high-school students perceive the personality of women researchers, what they think about some aspects of female scientists' personality and professional life; what is their idea about the role of women scientists in the scientific progress;
- investigate how high-school students consider cultural and social prejudices on women in science and in which way this could affect the career paths of young women scientists;
- propose an evaluation tool, a student-generated contents framework to be used by researchers to analyze student competition products.

6.2 Theoretical Framework

Learning theories, such as the cognitive constructivist theory (Bruner 1966) and the social constructivist learning theory (Vygotsky 1978), support the idea that meaningful learning happens when students are actively interacting with the learning materials (Long et al. 2016). The importance of images and the power of videos as potential tools to increase awareness and motivation concerning specific themes have been recognized since first movies were used as a training tool for soldiers during the Second World War (Cruse 2006). Furthermore, according to some authors, the process of generating and editing videos encourages a deeper level of understanding in students (Swain et al. 2003).

Several studies notice the role of technology in stimulating reflection and raising awareness in schools and how technological devices can be considered as a new tool developed for pedagogical use (Kearney 2011), able to transform the learning environments (Goldman 2004). These studies demonstrate that learner-generated videos and digital storytelling constitute a "valuable, transformative tool for learners in a range of curricula and discipline contexts" (Kearney 2011, p. 172). Furthermore, they sustain that enhancing learning through digital video projects improves motivation, social skills, self-expression and creativity, critical and reflective thinking and self-esteem (Kearney 2011).

6.3 Methods

A multidisciplinary team of physicists from INFN and sociologists from CNR designed both the school competition and the Gender in Physics Day event. The school competition was selected as a method to explore Italian students' prejudices, with the final aim of highlighting the perceptions and ideas of younger generations. The competition required students, individually or in group, to create an innovative

project (in form of a tale, reportage, video or comics) about stereotypes regarding women and science, highlighting female contribution to the advancement of scientific research. The competition targeted the last three-year classrooms of all types of high schools; students were requested to be mentored by at least one teacher.

The school competition explored students' perceptions regarding the prejudices embedded in the dominant culture concerning the role of female scientists in society. The contest was specifically addressed to high-school students because, as European data shows (European Commission 2015), the percentage of women who choose studying Science, Technology, Engineering and Mathematics (STEM) at university and at doctoral level is dramatically low (compared with men), while preferences and motivation for this career path are determined during high school (OECD 2015). Moreover, female researchers in universities and in laboratories still account for only 33% of the total research staff (European Commission 2015) and, even if women represent 47% in doctoral scientific paths, only 1/3 of them choose to study STEM disciplines.

Dissemination and advertising of activities for the school competition were performed using different channels: CNR and INFN institutional websites, social networks and a number of selected target groups mailing lists (schools, teachers, journalists, science magazines, etc.). An evaluation board composed by eight CNR and INFN staff—physicists and sociologists with experience in evaluating students' products and gender equality—ranked the students' results, using an evaluative grid specifically developed for this purpose. The criteria, presented in Table 6.1, included contents, creativity and the communication efficacy. For each criterion, a score from 1 (min) to 10 (max) was assigned.

The competition results and the winning products were presented during the first Italian Gender in Physics Day, held in Rome on May 10, 2017. The most relevant products were mainly videos, confirming the strong inclination of young students in using this kind of media. In addition, smartphone cameras and open software for video editing allowed students to produce quality products at no cost. This led the research group to focus on video contents, even though several kinds of products were also accepted. Therefore, the framework on how to read student-generated content presented below applies only to the videos submitted in the competition.

An ex-post questionnaire was sent to the students participating in the competition to explore their opinions regarding the competition experience and its impacts. A set of Likert-like scales were designed to collect students' opinions on women and science issues; the rating scale was defined between 1 (totally disagree) and 5 (totally

Table 6.1 Evaluation grid criteria for ranking the students' products	Adherence to the general competition focus on gender in science	Score from 1 (min) to 10 (max)
	Originality and creativity	Score from 1 (min) to 10 (max)
	Communication efficacy	Score from 1 (min) to 10 (max)

agree). In building the Likert-like scales, we considered the most popular expressions and themes resulting from the video analysis. Although an extensive content analysis of the videos was carried out, the current paper presents only the framework developed to evaluate student-generated contents.

6.4 Results

6.4.1 *Structural Data About Participating Schools*

A significant number of students participated in the competition and the ex-post questionnaire completed by participants showed a very positive impact on students' perceptions. We registered a great participation: 120 high schools, from all over Italy, and more than 830 students were involved producing tales, reportages, videos and comics. Six schools were awarded with different honorable mentions (best tale, most original message, best technical production, best reportage, most original expressive choice, best research of multimedia contents), and four schools were placed on the first three places (two schools with equal merit were awarded the third place). The winning products were broadcasted live for the Gender in Physics Day large audience and uploaded on a dedicated YouTube channel (https://goo.gl/9ukD48).

In this section, we present the composition of the participating schools sample. The data was collected by using the participation form sent to apply for the competition. Almost half of the participating schools were from the Southern regions of Italy (46%), followed by the northern regions (33%) and the central ones (19%). As shown in Fig. 6.1, a massive presence of Scientific High Schools was registered due to the proximity to the proposed theme. The pie chart shows the participation ratio per school type.

Figure 6.2 presents the gender composition of the individual teachers supporting the students in developing products for the competition and submit a proposal. Most

Fig. 6.1 Distribution of the types of schools participating in the school competition

Fig. 6.2 Gender distribution of teachers coordinating students' projects

of the coordinating teachers were women (86%), only 1% of the groups being led by a mixed-gender group of teachers.

6.4.2 Preliminary Findings: Students' Approval Rating on Stereotypes

In the ex-post questionnaire sent to the participating schools, we registered responses from 125 students, including 45 males (36%) and 80 (64%) females aged 15–18 years old. The results related to students' reflections following their participation in the school competition are presented below.

The first question was "Did you enjoy participating in the school competition?". For this question, no relevant gender-related differences were registered concerning the interest and involvement of students in this activity: Girls' average rank was 4.51 of the Likert scale, and boys' rank was 4.36.

The second question was "Have you ever thought about becoming a scientist in STEM?". The answers to this question highlight the male tendency to be more willing in pursuing a scientific career. Even if the absolute number of male and female students' declaring "very probable," their future as scientists was similar, remarkable differences appeared in the items "somewhat improbable" and "not probable," where the females exceed the males (Fig. 6.3).

The third question was: "In your opinion, what is the most relevant obstacle in choosing a scientific faculty at the university?". Girls declared that the major obstacle was the complexity of scientific disciplines (30%), followed by "do not perceive any obstacle" (25%) or the necessity to face off prejudices or other difficulties (15.6%). On the other hand, boys declared that the major obstacle is the complexity of scientific disciplines (20%) and the fact that scientific faculties are very demanding in terms of commitment (20.5%).

The fourth question was "In your opinion, do your family and your teachers encourage you in choosing scientific disciplines?". The results of this question showed that there are no relevant differences between girls and boys regarding family or school support.

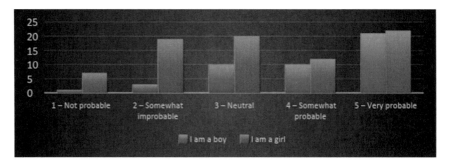

Fig. 6.3 Distribution of answers to the question "Have you ever thought to become a scientist in STEM?" for boys and girls (absolute numbers)

In the last section of the questionnaire, students were asked to express their opinions concerning some of most common stereotypes identified (by evaluators from CNR and INFN) during the evaluation of the products presented in the school competition.

As shown in Fig. 6.4, there is a general disagreement with the stereotype "Boys are more likely to succeed in scientific matter." These answers are certainly biased by students' participation in the competition and by the preparatory work done with the reference teachers. Nonetheless, they remain relevant judgments despite being formulated by students who have been informed about the topic.

However, we registered a strong disagreement between males and females on the stereotype "Girls do not fit with scientific career because they badly manage anxiety and stress" (Fig. 6.5). The stereotype according to which females badly manage anxiety was disagreed by a percentage of females that was almost double compared with the percentage of males.

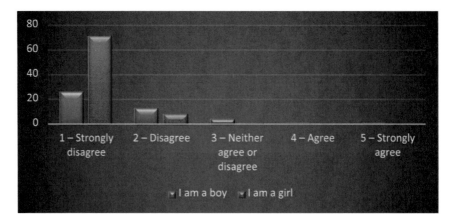

Fig. 6.4 Gender distribution of answers to the statement "Boys are more likely to succeed in scientific matter" (absolute numbers)

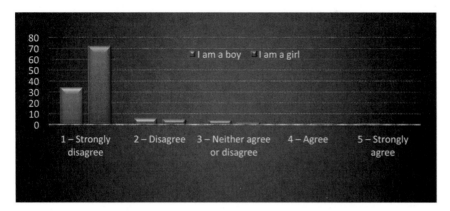

Fig. 6.5 Gender distribution of answers to the statement "Girls do not fit with scientific career because they badly manage anxiety and stress" (absolute numbers)

With the last item we aimed to explore social prejudice on how students perceive the stereotype according to which women should do a more flexible job, having to take into more consideration family-care responsibilities. Even if data showed that there is no prejudice concerning this issue, it is relevant to underline the high polarization of girls (almost the 50% of the sample) that expressed a very strong disagreement (Fig. 6.6).

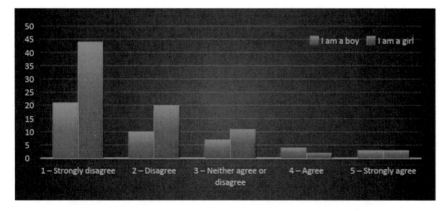

Fig. 6.6 Gender distribution of answers to the statement: "Scientific work presents complex working hours, women should have a more flexible job to take care of family" (absolute numbers)

6.4.3 How to Read the Student-Generated Contents/Products

Research teams from INFN and CNR produced a framework to analyze the student-generated contents, which had already been tested on the videos produced within the school competition. The student-generated contents framework aimed to analyze the relevant contents dimensions of the videos produced by students revealing the different communication layer and the characters' profiles and roles.

The framework presented below allows the analysis of the women in science theme but can also be used for contents in other disciplines.

The structure covers the following thematic areas:

- Editor's demographic data
- Demographic data of the characters presented in the storytelling
- Target audience
- Abilities (extraordinary/ordinary) of the characters present in the storytelling
- Characters' costumes and clothes
- Characters' social status (power in relationships, workplace or social group)
- Characters' transformation (modification of the status or of the explicit rules during the storytelling) (Fig. 6.7).

6.5 Discussion

The current study presents the results and the lessons learned from a high school competition organized with the aim of fostering students' critical reflections on women's role in science.

The preponderant participation of scientific high schools in the competition could be attributed to the topic of the competition, as well as to the closer presence of science teachers to the "gender in science" theme. It is relevant to take into account the relative low number of the participants from the classical lyceums, revealing a lower interest among the teachers and the students of those types of schools for the competition topic.

The high participation of female teachers highlights that women are closer to this kind of theme. Relevant is also the low percentage of groups led by mixed-gender groups of teachers (only 1%), revealing how difficult it is for different gender teachers to work together on such a topic and competition. Possible explanations could refer mainly to logistical reason (in organizing a double presence in the classroom) and secondly to the resistance of teachers for working in mixed-gender groups. This aspect would need to be further analyzed to better understand the causes behind the low collaboration among teachers.

The higher percentage of female students (compared to males) that answered "somewhat improbable" and "not probable" with reference to the possibility of becoming a scientist in STEM can be related, considering the OECD (2015), to

Structural data:		
Title of the product		
School typology		
Classroom		
Number of students by gender		
Number of foreign students by gender		
Town		
Town dimension		
Gender of the teacher coordinating the project		
Field of science of the teacher coordinating the project		
Synthetic product description:		
Title analysis	Language, title style, other.	
Topic: video refers to STEM or only to Physics		
Description of narrative and technical features:		
Narrative style	Presence or absence of the music	
	Music genre	
	Opinion about the music chosen	
	Use of animations:	Drawing
		Filming
		Technical difficulties
Typology of narrative style:	Fiction (students are actors)	
	Documentary	
	Personal testimony	
	Interview	Interviewed students,
		Interviewed university students,
		Interviewed teachers,
		Interviewed researchers
		Interviewed scientists
		Press report
	Other	
Women and men social representation:		
Historic reconstruction (it talks about the professional life of major female scientists)		
It takes evidence form statistics:		
It uses female scientists examples:	Historic (e. g. Marie Curie.)	
	Living person	
	Female scientists who succeeded during their life	
	Female scientists who got recognized after passed	
	Not so popular female scientists	
	List of the names of the scientists cited	
Female scientist images:	Iconic	
	Popular	
	Classic	
How female scientist images are represented:	Youth or elderly	
	At work, or somewhere else (to be specified)	
Visual traits, how they are represented:	Smiling	
	Serious	
	Peevish	
	Others (to be specified)	
The use of language:		
Cited values (e.g. culture, freedom)		
Use of adjectives while referring to women or men in the video		
Use of idioms		
Attention paid in using a neutral language		
Presence of prejudices		
Other		
Final message:		
Clear		
Emphasized		
Exhortative		
Metaphoric		
Other.		
Audience:		
The video is directed to a specific audience/target?		
If yes, to whom?	Students, general public, other.	
Students roles in end credits:		
Production		
Direction		
Editing		
Actors		

Fig. 6.7 Framework proposal on how to read student-generated contents

the low female perceived self-efficacy (Bandura 1977). Women tend to underestimate their skills and capabilities, and for this reason, they do not consider themselves as capable in fulfilling a scientific position. In what regards perceived obstacles for pursuing a scientific career, a factor that may hold back students, especially girls, is a lack of confidence in their own abilities and self-beliefs that could have an impact on learning and performance on cognitive, motivational, affective and decision-making levels (Bandura 1977; OECD 2015).

Regarding the perception of students in being supported by teachers and parents in becoming a scientist, equally registered for boys and girls, in our opinion, it reflects the gender-neutral support that teachers and parents offer during high school. In this sense, most of the prejudices are built in social contexts along with some early masculine characterization of the society, transmitted already at kindergarten and elementary school level (Bian et al. 2017).

The general disagreement with the stereotype "Boys are more likely to succeed in scientific matter" registered in the participating students can reasonably be strictly correlated to the participation in the school competition that raised awareness among students and stimulated dialogue within the classrooms and with the teachers regarding gender stereotypes. Agreement with this stereotype is still persistent in a small number of respondents, but this could in part be related to a spirit of adolescent conflict that has no relationship with the "gender in science" topic (Blankenburg et al. 2016).

Studies conducted by Long et al. (2016) show that students enjoy video creations as a learning tool because they can control the experience and they easily understand contents. It is also proved that this media instrument is more effective than the abstract way of analyzing the contents usually put in place by traditional school education (Buckingham 2007; Hobbs 2011; Hobbs and Moore 2013).

As suggested by Valente (2009), adding value to a process that leads from a crystallized knowledge (usually instilled by traditional scholastic scheme) by using fluid knowledge (provided by new learning tools) enhances meaningful knowledge. For these reasons, researchers, educators and teachers should consider the possibility of inserting new learning tools in the school curricula, shifting from a traditional way of conducting classes (instructor centered) to a more collaborative approach that enhances creativity and enthusiasm.

In our experience, the school competition turned out to be a very effective tool to sensitize students regarding Responsible Research and Innovation (RRI) topics and gender equality as a specific case study. According to our results, school competitions could be used as an educational tool for high-school students, with a relevant impact on group learning dynamics, increased awareness and active involvement of teachers.

Even if the results of this study are in line with those of similar studies, the context of the implementation of this case study limits the generalizability of the findings. The preliminary findings from the ex-post questionnaires, aimed at investigating the opinions of the students participating in the competition, represent an Italian case study, including a random sample of schools around Italy.

The evaluative student-generated contents framework we produced was tested on the specific topic "women in science" so further research is necessary to test the proposed framework with reference to other topics.

Finally, another relevant aspect of this experience is represented by the innovative collaboration between two major Italian research institutions on the specific topic "women in science" which also led to an internal debate on how to best tackle gender equality and gender prejudice in research organizations.

References

Bandura A (1977) Self-efficacy: toward a unifying theory of behavioral change. Psychol Rev 84(2):191–215. https://doi.org/10.1037/0033-295

Bian L, Leslie S, Cimpian A (2017) Gender stereotypes about intellectual ability emerge early and influence children's interests. Science 355:389–391. https://doi.org/10.1126/science.aah6524

Blankenburg J, Hoffler TN, Peters H, Parchmann I (2016) The effectiveness of a project day to introduce sixth grade students to science competitions. Res Sci Technol Educ 34(3):342–358. https://doi.org/10.1080/02635143.2016.1222361

Bruner JS (1966) Toward a theory of instruction. Belkapp Press, Cambridge

Buckingham D (2007) Beyond technology. Children's learning in the age of digital culture. Polity press, Cambridge

Cruse E (2006) Using educational video in the classroom: theory, research and practice. M.Ed., Curriculum Director, Library Video Company

European Commission (2015) She figures

Gender in Physics Day YouTube Channel: https://goo.gl/9ukD48

GENERA Website: https://genera-project.org

Goldman R (2004) Video perspective meets wild and crazy teens: a design ethnography. Camb J Educ 34(2):157–178

Hobbs R (2011) Digital and media literacy: connecting culture and classroom. Corwin, Thousand Oaks

Hobbs R, Moore DC (2013) Discovering media literacy. Teaching digital media and popular culture in elementary school. Corwin/Sage, Thousand Oaks

Kearney M (2011) A learning design for student-generated digital storytelling. Learn Media Technol 36(2):169–188. https://doi.org/10.1080/17439884.2011.553623

Long T, Logan J, Waugh M (2016) Students perceptions of the value of using videos as a pre-class learning experience in the flipped classroom. TechTrends 60:245–252

OECD (2015) The ABC of gender equality in education: aptitude, behaviour, confidence. OECD Publishing, Paris

Swain C, Sharpe R, Dawson K (2003) Using digital video to study history. Soc Educ 67(3):154–157

Valente A (2009) Dal Metaplan all'Open Space Technology: integrare un percorso partecipato nella scuola. In: Valente A (ed) Science from specialists to students and back again. Biblink Editori, pp 39–56

Vygotsky L (1978) Mind in society: the development of higher psychological processes. In:. Cole M, John-Steiner V, Scribner S, Souberman E (eds). Harvard University Press, Cambridge

Chapter 7
The Artists' Voices as an Inspiration for Intercultural Practices, Art–Science Paths and Innovative School Curricula

Elisabetta Falchetti and Maria Francesca Guida

Abstract This chapter presents suggestions, hints and models of creative intercrossings between art and science and of inter-trans-cultural/disciplinary approaches in educational practices and curricula. Two artists express their visions through interviews carried out by the authors. Two projects implemented by the authors together with artists confirm the value of intercultural experiences of art and science in educational, socially oriented processes involving values, participation, responsibility and citizenship, in a real socio-environmental scenario, with projection towards future actions of a community.

Keywords Cross-trans-culturality · Art and science · Curricular innovation · School projects · Citizenship · Participatory methodologies · Points of view of artists

7.1 Introduction

Art and science are two forms of human thinking and interpreting reality, historically inclined to cross their disciplinary boundaries and shift one in the other, following the cultural trends of the various epochs and places. Their visions, epistemologies and practices are distinct but can be integrated to create challenging, exciting experiences and products, enabling each other to improve their understanding of the world phenomena.

Many forms of art can create interconnections with science and give meaningful inputs for the comprehension of scientific topics. Scientific museums represent an example of this winning approach. They are protagonists of a deep revolution in introducing aesthetic and artistic approaches in their exhibitions and educational

E. Falchetti (✉) · M. F. Guida
ECCOM (European Centre for Cultural Organization and Management), Via Buonarroti, 30, 00185 Rome, Italy
e-mail: falchetti@eccom.it

M. F. Guida
e-mail: guida@eccom.it

© The Author(s), under exclusive license to Springer Nature Switzerland AG 2021
P. Sandu et al. (eds.), *Co-creating in Schools Through Art and Science*,
SpringerBriefs in Research and Innovation Governance,
https://doi.org/10.1007/978-3-030-72690-4_7

pathways, in experimenting manifold artistic activities (theatre, visual arts, music, dance, photography, etc.) and interventions of artists to improve cultural accessibility and understanding of their collections and promote audience development, in particular of young people and migrants. Their initiatives enrich and facilitate learning and appreciation of the scientific experiences in museums. Many researchers, universities (e. g., Stanford with its art and science courses) and institutes (e. g., the Italian National Institute for Nuclear Physics—INFN with the programme "Art and Science across Italy") are working at the cross-road of the two cultures. On the other hand, science inspired in the past and still inspires a lot of contemporary artists generating for instance the "scientific art", joining deep emotional experiences with scientific concepts.

7.2 The Artists' Voices

One of these artists is Michela de Mattei, that the authors have followed in her path of experimentation of this trans-cultural art and interviewed about her vision. Her artistic research is intimately linked to her interest in natural sciences. She released the following amazing interview for this paper.

> The relation between art and science is fundamental to my practice. My personal artistic research is linked to the relationship between humans and animals; therefore, science is a constant inspiration. Many of my works have indeed started from the reading of scientific papers, or from exchanges with biologists and teams of scientific researchers.

> For example, my most recent video, which focuses on aquariums and marine life, has been deeply influenced by scientific studies, in particular by the dialogue that I initiated, over the past year, with a research project from the Plymouth Marine Lab, who is investigating the impact of artificial light on marine ecosystems. The video in fact addresses the question of nocturnality from a poetical and visual point of view. In general, my works questions the relationship between human and nature, playing between fiction and reality. It is thus always very important to ground my research in scientific knowledge in order to make free associations and orchestrate my personal narratives around the animal world.

> Working together with scientific researchers is always one of the most interesting stages of my works. It allows me to collect data and information around animal behaviors, to start new conversations and expand my vision through new collaborations; but also to experiment innovative technologies. I often use scientific observational approaches and methods, like thermal cameras, interfaces, or technical systems of monitoring, including them in my filming and means of representation, as tools to enrich my personal aesthetic. More generally, I also believe that <<authoriality>> in art is nowadays outdated and artists have the chance to activate more collaborative forms that are essential to create and develop new territories in the field of art.

> My experience working closely together with scientists and researchers from different fields like biologists, psychologists or anthropologists has been profoundly fruitful, for both me and my interlocutors. Actually, we often found ourselves working in a very similar way, through a very experimental approach. For example, we try recreating a determined world with specific elements and introduce an element of disruption (that for me is mainly a poetical factor) in order to observe the consequences. It is very interesting to see how scientists and

artists put the same intensity of attention when looking at things and processes, even aiming at different outcomes.

Art and Science working together could have a role in engaging people to a more ecological way of inhabiting the world and sharing it with other species. For scientists, raising awareness on certain issues can be very difficult. For example, communicating what are the effects of light pollution on the underwater world is not an easy task, probably because as humans we are less able to empathize with marine creatures that live in a completely different environment than ours. In this sense, art, working on an emotional level, might be very helpful and more effective in <<moving>> people.

To mention another example, in 2019 I did a show in London around the phenomenon of "Blushing". My research started with the discovery of an online platform connecting people suffering by this sudden rush of redness on their face, due to panic disorders or social anxieties. I did different interviews, trying to record the blush on camera with some of them, asked some psychologists to contribute to my research, and also made a new body of paintings using a thermo-chromic paint. The show explored the topic from different points of views, looking at it from different perspectives: in animals, in humans and in some materials. Metal, for example, must reach a certain change on temperature (becoming red and almost liquid) to change shape. I think that in a poetical way, this is exactly what happen to humans, they always have to pass through their most vulnerable state in order to make a change. Finding poetical associations and similarities between different fields, species, materials is for me an enriching challenge in the knowledge development process.

Looking at something through the artistic lens means for me making an effort to consider visual/sound clues, understanding a situation from the most perceptual point of view, in order to then be able to translate and reproduce it in my artworks: using video, sculpture or any other medium to create a feeling into the viewer. In my experience, the addition of an artistic and poetical point of view has been for my scientific interlocutors very productive and challenging, adding to their project a new perspective, free from any functional conclusion, or any rigorous justification.

Introducing artistic languages into scientific approaches might be a resource: to push the boundaries of thinking into a poetical extreme, or into an absurd scenario, that could appear out of logic and functionality, but might be able to help understanding or feeling the behavior of a different species, a completely different being that is in a way very similar to us, but it is not us.

The alliance of art and science can create opportunities to achieve—in and out of school—the new 2018 EU Agenda for Culture goals, namely creativity and creative thinking and the "Lifelong Competences for the 21st Century", as critical thinking, problem solving and emotional skills, as empathy, imagination, curiosity, wonder, emotional intelligence, ability to perceive and appreciate diversity to explore different horizons, meanings, possibilities and solutions (Council of the European Union 2018). Both art and science contribute to the construction of basic, transversal, soft skills, but art opens other mental attitudes, for its intrinsic cultural enrichment as well as for the educational, eye-opening, cognitive impacts, engaging languages, exciting products and performances.

"Creative acts" are rare at school and teachers generally prefer stable, comfortable disciplinary pathways (Kagan 2013). The main pedagogists agree that artistic activities improve a culture of creativity at school, empower the imaginative potentiality of students and enhance motivation, autonomy, self-esteem and awareness of their own talents. In Italian school, art is limited to a very short time, under the "history of

art" approach; the aesthetic experience is poorly valorized and improved, despite its neurological, physical, spiritual and emotional impacts in the individual formation and in a community cultural orientation. Only in the artistic high schools (Liceo artistico), there are some opportunities to practice studio arts or laboratory activities. Experiences that intercross art and science are uncommon, despite their creative and innovative potential.

We face various pedagogical contradictions, as emphasized by Stefano Cataldi (musician and composer with whom the authors have established a creative collaboration) in the following interview.

> I have no doubt regarding the fundamental value of art in the human formation, starting with school-aged young people. From them I learned about a painful contradiction (of my views) with the current educational system. I'm speaking about the Italian school, because I live and I studied here, but I can compare our system with the American one, where I also studied and taught, and the Anglo-Saxon one, of which I have a good understanding.

> The educational system, globally, is losing the capacity to place Art at the rightful position in the citizen education. Art has always woven a relationship with other disciplines, but today we face a paradox: <<No, No... I don't like math; I play music; I'm an artist...>>; I often gather similar assertions from young people. I do not blame them; responsibilities are elsewhere. Yet, it would be easier to start the students' education from the math of the sound, to help them understand that each body reacts individually to sound vibrations depending on personal anatomy, from the shape of the bones that although identical in numbers (in the human being born with the chance to be anatomically normal) are qualitatively different in each of us and reacting differently to vibrations. The same voice tone, that is our ineffaceable timbre, derives from these differences. I'm speaking about quite tangible elements, representing our microcosm, easy to understand for every "trained" educator. After that, it would be possible to move on to the mind, emotions, philosophy, to other arts, so that magically we could have <<human beings>>, shaped by the knowledge of art, governing the nations.

> It's not casual that our civilization - among whose ruins we prowl frenetically as zombies - was born from the Trivium education: grammar, rhetoric, dialectic and from the Quadrivium education: arithmetic, geometry, astronomy and music. Trivium and Quadrivium were considered an "unicum", the fundamental base for education. Today, Leonardo da Vinci would not be allowed to train...today we have experts with certifications, with pile of useless scraps of paper expensively obtained both in economic and human terms, that are frequently awful obstacles to a true formation. They are rather homologating instruments useful to reset the differences that make nature so beautiful and varied and that allowed the lowly and enchanted human being to mirror him/herself in it, with the desire of understanding nature and observing it in a respectful silence. Art teaches us to love each other in the differences and characters that make each individual unique and incomparable.

> I see many problems, especially in regards to the new generations, that I meet every day as students/pupils, and thanks to my two daughters and their friends that are becoming for me a research field. They are hungry for knowledge but frequently deprived of the possibility to learn. The artist is too much mixed up with the jocker, with the trickster. Media presented to people an idea of the artist fully deformed. For longtime the artist has been considered crazy, naturally gifted with creative talent, one who, between a drug and another, makes "art", considered as a profitable short-cut to face life without the sacrifices required by every conquest. In the world in which our young people are permanently immersed, all are artists and, dear me, we are losing the meaning of what Art is.

> True Art dignifies everything because it is generated by the artist's sacrifice. The artist must be an excellent artisan; each of us could become such, just devoting himself/herself to his/her own activity with integrity and accuracy. This is the last point about the relationship between

art and the new generations. The "homo faber fortunae suae" contributed to the technology advancements; today, young people play music by using software that give them the illusion of being able to play. The man who wants to know and learn is a man that gets his hands dirty, tries to relate constantly to "lower and higher things". For example, he strives to observe a leaf, to understand its structure and relate it to a musical shape. For this powerful conceptual endeavor, he needs a primordial emotion: wonder. Wonder constitutes for the artist a real drive towards the order that he/she will express in his/her artwork. I note in many young people that I meet the lack of sound/healthy wonder capable of driving them to make acceptable, even great sacrifices. I am sure that our young people need confident, reliable leadership to indicate the path. The experience lived with the students at the Mercati di Traiano confirms my impression.

7.3 Case Studies of Projects Joining Art and Science

The integration of artistic approach and activities is a statement for the authors' projects, no matter their disciplinary fields and social/educational aims. Our methodologies embrace multi-inter-trans-cultural strategies, languages, topics and build collaborations with a variety of actors, institutional and civil society partners. School is one of the authors' work-field, with the goal of collaborating for innovative curricula, transformative (transgressive?) didactic and education, inspiring new languages, narratives and performances.

The two following projects "Green Routes" and "Live Museum Live change" are examples of this strategy.

7.3.1 The Project "Green Routes" for Environmental and Social Sustainability

Taranto (Puglia Region, Italy) is a wonderful city affected by a dramatic pollution (due to a large steel manufactory) that has changed the city aspects, life styles, aspirations and wishes and has obscured the inhabitants' visions regarding their future. The city is facing a complex socio-ecological problem, materialized in a conflict between public health and employment–local economy. Young people, students, are not able to look at their lives optimistically. The project "Green Routes" carried out by the authors in partnership with many institutional and social actors (see www.greenrout es.it) intended to engage the local population in a participative process to design (or to wish) more sustainable scenarios and futures, by little but meaningful interventions of urban ecological and social regeneration and educational pathways for sustainability.

Sustainability is a matter and a very complex domain of interrelated problems and interventions. Science, namely ecology, gives some answers (with contested approaches between deep and shallow ecology) to environmental–ecological issues, but the "sustainable education" that should act on the "change of thinking" shifted in the last twenty years from a purely ecological to an interdisciplinary approach,

including art both as support to scientific topics and as a method of reality interpretation (e. g., Morin 1999, 2000; Sterling 2001; Lotz-Sisitka et al. 2015).

Poetry, visual arts, theatre and other forms of art have inspired and enlightened the new sustainability education. The project Green Routes hired many artists through a public call and gave a wide creative space to them, their suggestions, hints and performances. One of them was Guendalina Salini—a Roman artist active in the national and international arena (see www.guendalinasalini.info)—with the commitment of activating the local students' and other citizens' imagination and participation by artistic performances and artworks related to Taranto landscape, nature and sustainability. In an interview, Guendalina expressed her intent to "Sprout and raise words of hope for Taranto". She launched participative laboratories in many private and public symbolic city places for the creation of an artwork in which students and other citizens had to write and draw on the ground some words, using seeds of ancient wheat, to express their hopes, feelings and ideas germinating and growing. The "words" were cultivated by the community and fostered "green and living narrations" in houses and urban environments, inspiring revitalization and ecological transformation. After the "birth" of the seeded words in the city, the artist realized a final artwork "Paesaggio indeciso", sending a message about the resilience of nature.

"In this setup I split a grey stone sheet resembling the asphalt and I put among the cracks some thyme and other spontaneous native plants to simulate that local nature, with its inner vital strength, has regained space, breaking the stone that stifled it". This artwork was installed in the backyard of the city Conservatory, also as a metaphor of the strength of culture and music, good for urban regeneration.

The laboratories organized by Guendalina have also ignited the students' motivation and imagination. Some high-school classes (IISS Vincenzo Calò of Taranto and Agrario of Massafra) worked for the initiative "Green Garden Collective", that engaged the same students and other citizen in a series of micro-projects to create a widespread garden in the city of Taranto. The students experimented "ecological art", realizing little artistic gardens to place in the most polluted—run down City neighbourhoods, entrusting to their inhabitants the task of taking care of them. This strategy introduced to the community problems such as ecological sustainability, civic responsibility, proposing ideas for the city regeneration. Green Garden Collective generated a coral pathway that engaged the city community.

Following this experience, the students improved their contacts with ecological problems and learned about eco-biological features of local vegetation and of antipollution and resilient plants. Chemical and other scientific points of view were introduced and the students also received and elaborated a responsible civic-social message for recovering ecological relationships, reconciling community and environment and emphasizing the beauty of nature, thanks to the artistic inspiration. The power of beauty for inspiring awareness towards environment is acknowledged (Kagan 2013): "beauty" as an element of sustainable thinking and acting and as an educational multi-, inter-, trans-disciplinary tool.

7.3.2 The Project Live Museum—Live Change

A lot of disciplinary issues and curricular arguments can be approached by Heritage Education. Therefore, this is a domain in which students can face disciplinary topics, but also territorial problems that hire civic responsibilities. Therefore, many school projects carried out by the authors encompass multi-perspective and multidisciplinary experiences on cultural heritage.

"Live Museum Live change" was a project aiming to rediscover and valorize the cultural and social values of a unique archaeological site: the Mercati and Museum of Traiano in Rome. Also, in this project the authors engaged students, artists and other social actors to foster different visions of the site and emphasize various approaches to its knowledge and interpretation (see https://traianolivemuseum.com/). Many artists answered to the public call and worked in partnership with experts, students and common citizens. Within a wide range of initiatives, some classes of two Roman high schools (Liceo Mamiani and Liceo Dante) were engaged for the realization of new experimental narrations of this cultural heritage inspired by and in collaboration with artists.

Among these intercultural–interdisciplinary experiences, it is noticeable the production of the "Taccuini botanici" (Botanical notebooks), combining art and science, realized by the young artist Gaia Bellini (see https://www.singulart.com/it/artista/gaia-bellini-11443) during a pathway including groups of students, that reinterpret and valorize the site by the natural elements living there. The Notebooks contain a chromatic inventory of the botanical species of the site, after the extraction and the transformation of their natural colours and the print on books. The plants have been classified by their botanical features and names and by this special chromatic inventory. Gaia's suggestion was to perceive and describe a place by its shape and natural colours. Nature is the vital element of Gaia Bellini's artistic research and poetics, and the colour is her expression. "My research… wants to create … the identity of a place, as of a person, by what is living there… The Mercati di Traiano are a site where the material elements narrate vital cycles that, in connection with the natural ones, suggest birth, evolution, continuous transformation. My artistic Books should call all people to rediscover the beauty that educates". In the research carried out by the students with this artist (they also realized some "mood stories", by photographs of the natural elements of the site) arises a thought about nature, its resilience, impermanence, its power of integration with human elements/artefacts, but also feelings, emotions suggested by the site and the value of its conservation.

Another relevant experience was carried out by one of the classes directed by the musician and composer Stefano Cataldi. This artist, together with the students, converted the main themes, sounds and architectural shapes of the site in music, creating a sound geography image of the Mercati di Traiano. The composition (entitled "Timeless Mercati … at the boundaries of the sound") was realized after various activities: visits at the site; an observation and "rationalization" of the site's architectural shapes to identify rhythmic elements and features to translate into musical rhythm; debates about its cultural values; interviews to visitors; recording of local

sounds/voices; a study of ancient musical instruments; exploration of some classic-formal music compositions; and, finally, an electronic transformation of all the audio recordings and of the architectural rhythms. This musical composition was placed at the site for a new unique narration that combined the physical–objective experience and the artistic one, with a great reward to students and the artist for the product in itself, but also for their active participation in a social–cultural and citizenship project.

All the students, teachers, artists and other participants worked in a creative, harmonious partnership, nourishing the inter-generational, interdisciplinary, inter-expert dialogue and generating new co-produced forms of knowledge and culture rewarding for all.

7.4 Conclusions

The interview with Michela de Mattei provides an invaluable point of view from the world of art on the mutual intellectual and emotional input of the experiences placed at the intersection between art and science. Her statements could be broaden to other interdisciplinary–intercultural experiences crossing different visions, epistemologies and sensitivities.

The interview with Stefano Cataldi expresses the artist's awareness of the intellectual, practical benefits and the contribution in "humanity" supplied by the artistic practices for educational purposes, as well as the awareness of the intellectual and spiritual deprivation in absence of art.

The two authors' experiences/projects provide an example of valid intercultural practices in the school pathways generally based on the classical disciplinary study and support the option to develop innovative school curricula, in a Responsible Research and innovation (RRI) perspective, able to create or improve recommended skills and creative knowledge, as well as citizenship, participative and responsible attitudes, because they offer more opportunities to meet and face real and problematic contexts, territorial issues, matters of sustainability and future.

Artists' participation is critical to activate new competences, perspectives, visions, interpretations, emotional participation, creative thinking and motivation. Likewise, the engagement of different actors, professionals, institutions and civic agencies enriches the educational experiences with different ways of thinking and practical models that are usually excluded by the current schools' horizons.

References

Council of the European Union (2018) Council recommendation on key competences for life-long learning. https://eur-lex.europa.eu/legal-content/EN/TXT/PDF/?uri=CELEX:32018H060 4(01)&from=EN

Kagan S (2013) Art and sustainability. Connecting patterns for a culture of complexity. Transcript Publishing. ISBN 978-9-8376-1803-7

Lotz-Sisitka H, Wals AEJ, Kronlid D, McGarry D (2015) Transformative, transgressive social learning: rethinking higher education prdagogy in times of systemic global dysfunction. Curr Opin Environ Sustain 16:73–80

Morin E (1999) La tête bien fait. Repenser la reforme, reformer la pensée. Seuil

Morin E (2000) Les sept sovoires nécessaires à l'éducation du future. Seuil

Sterling S (2001) Sustainable education. Revisioning learning and change. Schumacher Briefings

Chapter 8
Lessons Learned from Educational Methodologies Using Art and Science

Petru Sandu, Valentina Tudisca, and Adriana Valente

Abstract Co-creation and other Responsible Research and Innovation (RRI)-related principles and tools can be successfully applied in the field of art and science, valorization of cultural heritage, giving value to territory, community development, innovation and well-being and promoting gender equality in science. By the use of modern, digital techniques adapted to their capacities and preferences, millennials can be attracted into active community participation, be delivered relevant education in art and science, equipped with necessary hard and soft skills for the twenty-first century work market and empowered to assume leadership roles in preserving the cultural heritage and territory of their communities, making them relevant and sustainable, socially and economically.

Keywords Art and science · Participatory approaches · Co-creation · RRI · Education

Although inapparent to the untrained eye, art and science share an important number of attributes, methods and instruments, both require rules but also creativity and each can foster advancement in the other's domain.

Despite of these similarities and complementarity between art and science, school systems do not generally incorporate these two topics jointly in educational processes and do not promote Science, Technology, Engineering, Arts and Mathematics (STEAM), referred to combining art and science as a general practice, depriving current generations of hard and soft skills that, according to education work market studies, seem to become—or even already be, in some fields of activity—invaluable.

P. Sandu
University Babes-Bolyai, Cluj-Napoca, Romania

V. Tudisca (✉) · A. Valente
Institute for Research on Population and Social Policies of the National Research Council of Italy, Rome, Italy
e-mail: valentina.tudisca@irpps.cnr.it

A. Valente
e-mail: adriana.valente@cnr.it

© The Author(s), under exclusive license to Springer Nature Switzerland AG 2021 71
P. Sandu et al. (eds.), *Co-creating in Schools Through Art and Science*,
SpringerBriefs in Research and Innovation Governance,
https://doi.org/10.1007/978-3-030-72690-4_8

At the same time, educational participatory approaches related to connections between art and science, including STEAM and storytelling, can help to successfully address social challenges, community innovation and well-being through an inclusive process, as it should be. As a matter of fact, the real-life case studies included in the current volume show that these approaches can allow to detect the real needs of communities and foster the collaboration with relevant stakeholders, transforming schools into agents of community well-being, innovation and development.

This volume includes a collection of real-life case studies incorporating art and science in the more complex frameworks of participatory approaches to education and Responsible Research and Innovation (RRI). The purposes are stimulating co-creation in research and education, community development and well-being, giving value to territory, promoting the cultural heritage, supporting gender balance in science, by using modern, attractive, digital methodologies (such as digital story-telling) to produce easy to disseminate digital products, relevant for the current generation of young people as part of their own cultural identity. A synthesis of the conclusions derived from the case studies presented *in extenso* in this volume follows.

Valorization of the cultural heritage by the means of digital storytelling can contribute to improvements in students' digital competences (oral, written, visual), literacy and communication, interpersonal social and civic competences and to the development of students' transversal and soft skills, scarcely cultivated in the traditional curricula, but fundamental in a RRI approach: relational and communication skills; autonomy and self-esteem, enthusiasm, self-motivation and awareness, social and co-operative skills (such as working in group/different teams, building partnerships and involving other people; empathy; interests toward their communities; ability to plan and project management).

The use of *crowddreams* implies starting from an individual insight, creating a compelling story about a desirable future and developing from that story a well-designed innovation project that can shape the shared dream into a reality. The implementation of a crowddream originated project can lead to population wide positive outcomes, such as increased community engagement, cultural heritage appreciation and capitalization, young people feeling they can build own places in the community, but also quantitative benefits such as creation of workplaces, active involvement of young people and other stakeholders in community initiatives and increase in the number of visitors of developed projects, such as museaters.

Open Schooling methodology, that involves schools and other community stakeholders to become agents of community well-being, through a variety of community oriented educational activities, can address issues such as limited access to STEAM education, high rate of school failure, demotivation and drop-out, low innovation and reduced capacity for investment and entrepreneurship and lack of collaboration among entities from remote or undeveloped regions, even from developed countries. A variety of community-oriented educational activities can promote the development of student-led projects based on the real needs of the community and foster the collaboration with relevant stakeholders, transforming schools into agents of community well-being, innovation and development.

The use of Learning Science Through Theater (LSTT) methodology, that includes scenario writing, music composition, designing sets, costumes and developing choreographies, can establish a culture of scientific thinking and promote a deep conceptual change in policymakers and stakeholders, educational institutions and school communities, promoting different perspectives of knowledge. Previously unexplored RRI key aspects can be experienced during a LSTT initiative, leading to acting and thinking differently about science in both teachers and students.

Gender-based stereotyping regarding the unfitting of girls in careers in the scientific disciplines can be addressed and mitigated through tales, reports and videos about gender equality in scientific careers and women's roles in these disciplines. School competitions can be effective tools to sensitize students regarding Responsible Research and Innovation topics and could be used as educational tools for high-school students, with a relevant impact on group learning dynamics, increased student self-awareness and teachers' active involvement.

Curricula innovation and the creative use of art and science in an inter-transcultural disciplinary approach can lead to acquisition of innovative cultural perspectives and interpretations, emotions, hopes, wishes and values. The perspectives of artists, regarding the existence of mutual intellectual and emotional inputs of the experiences placed at the intersection between art and science and the raising awareness of the intellectual and spiritual deprivation in the absence of art, are invaluable in the process of integrating art in science education, within a more complex and comprehensive framework of community participation, co-creation of concepts, products and values, and adherence to RRI principles.

More generally, a STEAM approach to education embedded in the broader frameworks of co-creation, community participation and Responsible Research and Innovation can result in multiple benefits from an individual level (increasing knowledge, awareness and skills of students, teachers and other actors involved in the collaborative projects), to the community level (promoting innovation, social cohesion, well-being, valorization of cultural heritage and economic development). RRI concepts, principles and tools could be used both symbolically and instrumentally for incorporating the current social needs and values into research projects, educational and community interventions. Schools, families and local communities have to engage collaboratively in promoting innovative learning methodologies and instruments, adapted to the needs, capabilities and interests of young people/students, so as to foster their engagement in solving social problems relevant to their community and identify themselves as central change agents in a fast-pace changing world. Similar initiatives to the ones presented in the current volume should be promoted, in order to validate and contextualize the value of co-creation and RRI in art, science, valorization of the territory and community development.

Index

Printed in the United States
by Baker & Taylor Publisher Services